A GANNETT COMPANY

PICTURE PUZZLES
Across America 2

Play these other fun puzzle books by USA TODAY:

USA TODAY Sudoku
USA TODAY Everyday Sudoku
USA TODAY Crossword
USA TODAY Logic
USA TODAY Mini Sudoku / Sudoku X
USA TODAY Word Roundup / Word Search
USA TODAY Word Play
USA TODAY Jumbo Puzzle Book
USA TODAY Picture Puzzles
USA TODAY Everyday Logic
USA TODAY Jumbo Puzzle Book 2
USA TODAY Don't Quote Me®
USA TODAY Txtpert™
USA TODAY Picture Puzzles Across America
USA TODAY Word Finding Frenzy
USA TODAY Crossword 2
USA TODAY Logic 2
USA TODAY Sudoku 3
USA TODAY Up & Down Words Infinity
USA TODAY Crossword 3
USA TODAY Word Roundup™

PICTURE PUZZLES
ACROSS AMERICA
2

**Andrews McMeel
Publishing, LLC**

Kansas City • Sydney • London

Andrews McMeel Publishing, LLC
an Andrews McMeel Universal company
1130 Walnut Street, Kansas City, Missouri 64106

12 13 14 15 16 WKT 10 9 8 7 6 5 4 3 2 1

ISBN: 978-1-4494-2169-4

www.andrewsmcmeel.com
puzzles.usatoday.com

Puzzles by Quadrum

ATTENTION: SCHOOLS AND BUSINESSES

Andrews McMeel books are available at quantity discounts with bulk purchase for educational, business, or sales promotional use. For information, please e-mail the Andrews McMeel Publishing Special Sales Department: specialsales@amuniversal.com

INTRODUCTION

Take a photographic road trip across America with the picture puzzle pros at USA TODAY—back again with a new collection of eye-crossing puzzles guaranteed to exercise your gray matter in the most entertaining way possible! Most of the picture puzzles included here are our version of spot-the-difference games. We've also included an assortment of "Which picture is different?" puzzles.

A few tips for solving these puzzles: As you compare the seemingly identical pictures, view each photo as a grid. Start at a corner and compare that section to the same section of the opposite picture. Continue working through the pictures section by section, carefully comparing every element.

Good luck!

Easy
Street

GRILLED FOR ANSWERS

One of these Fourth of July BBQs is all sizzle and no steak. What's amiss?

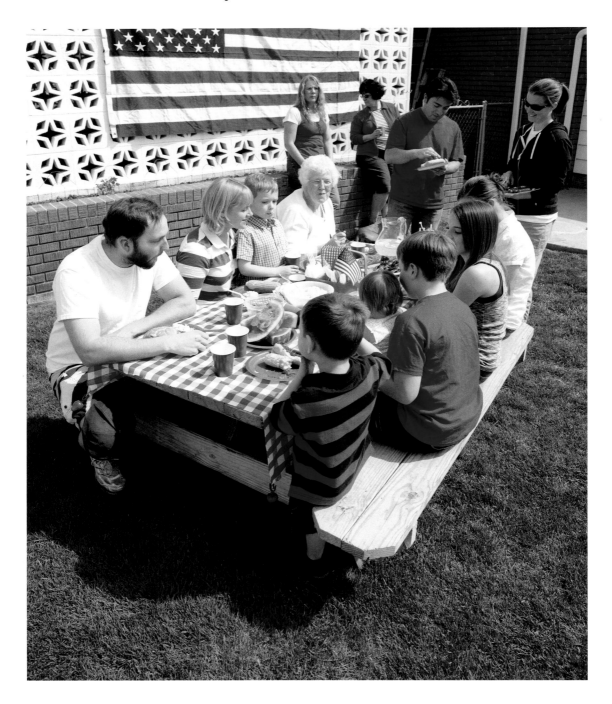

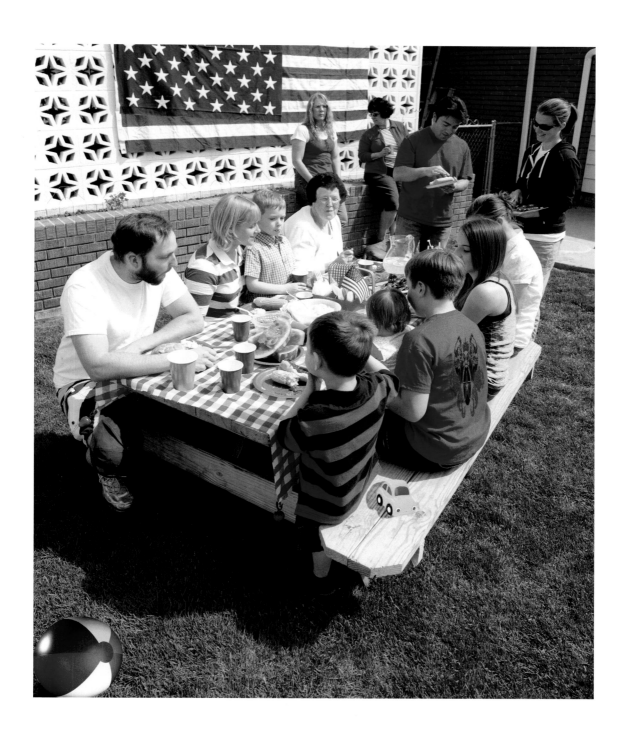

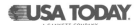

STARS AND STRIPES FOREVER?

Even a picture-perfect family like this one can't hold a pose all day.

GOGGLE GOBBLE

One turkey has all the fixings, and the other needs some fixing.

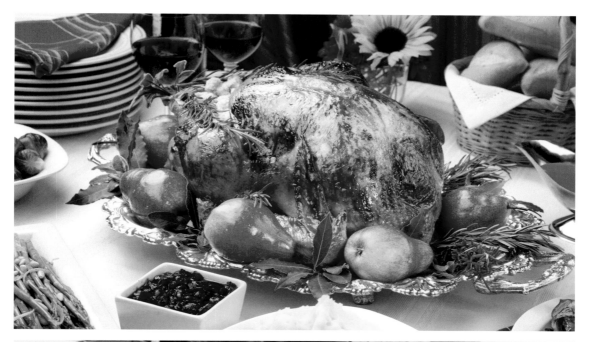

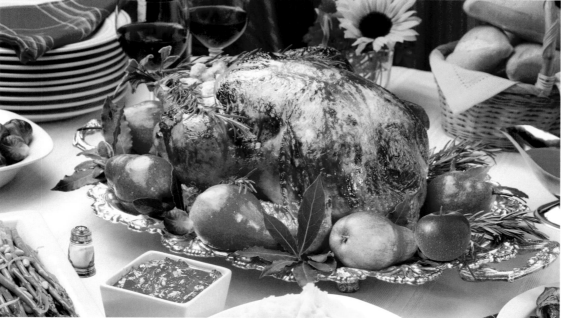

6 Changes ⬡ ⬡ ⬡ ⬡ ⬡ ⬡

SHELL GAME

Easter egg rolling has been a White House tradition since 1878.
Stay on a roll and spot the differences in these photos.

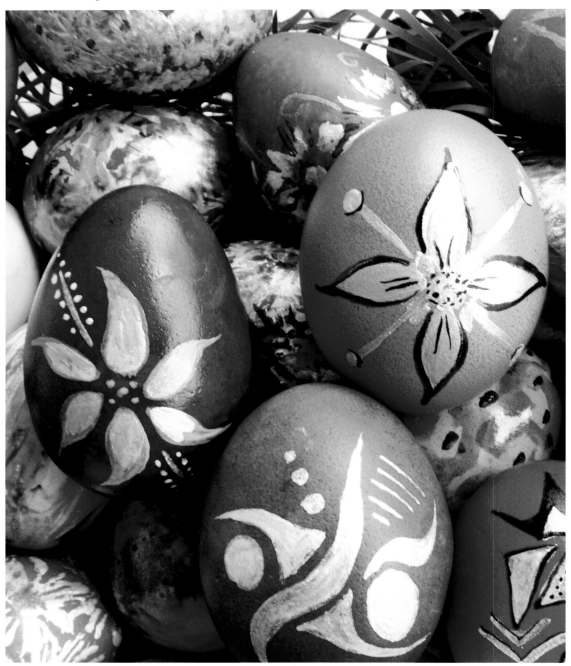

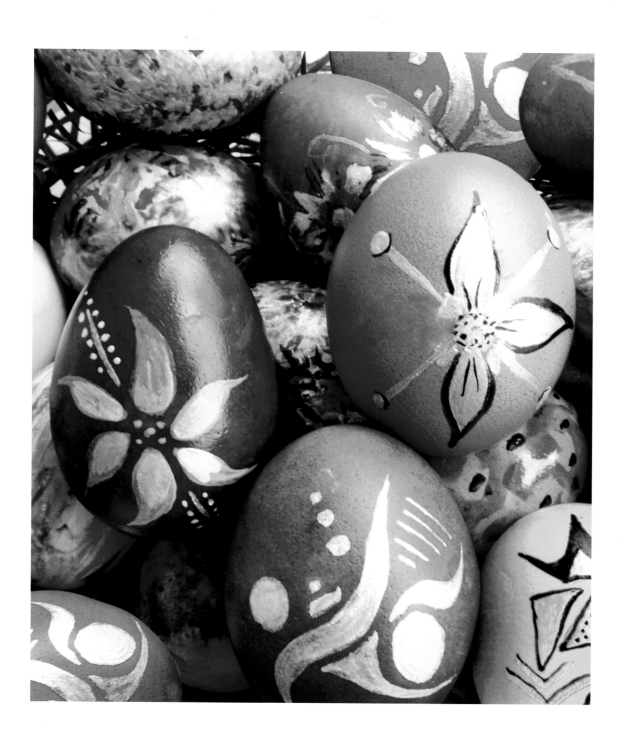

"SPOKEN" LIKE A GENTLEMAN

"Wheel" be darned if you can't spot the odd bike out.

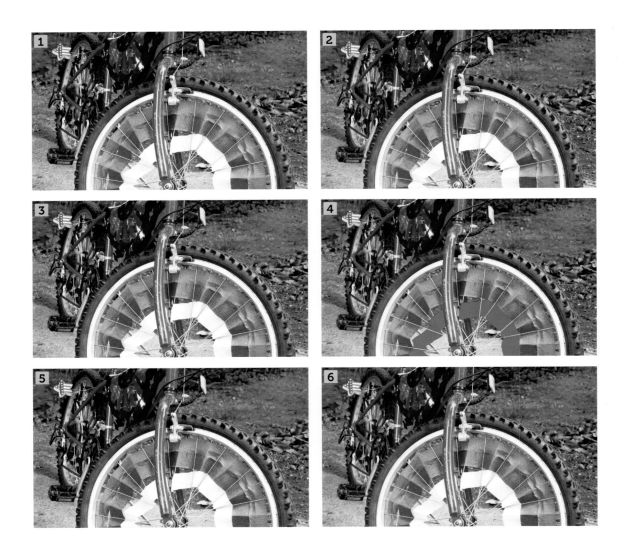

BERRY NECESSARY

Turkey without cranberry sauce is as unthinkable as Thanksgiving without turkey. What else has made it to the table?

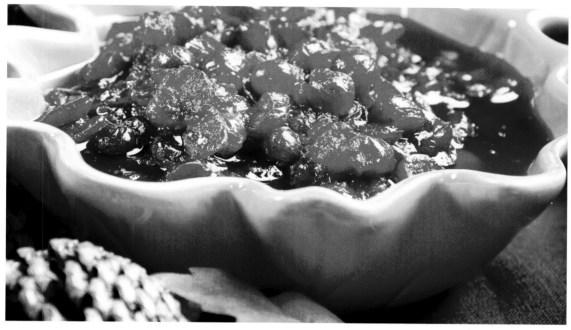

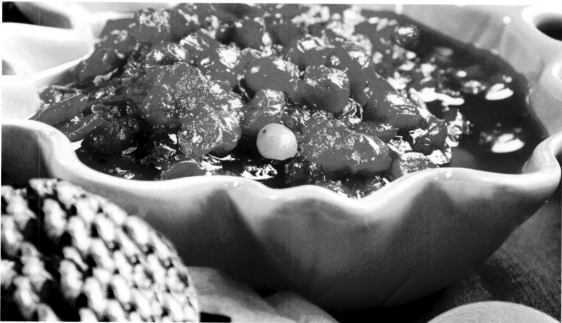

FREEDOM RINGS ...

... but this Liberty Bell replica in Washington, D.C., may not.

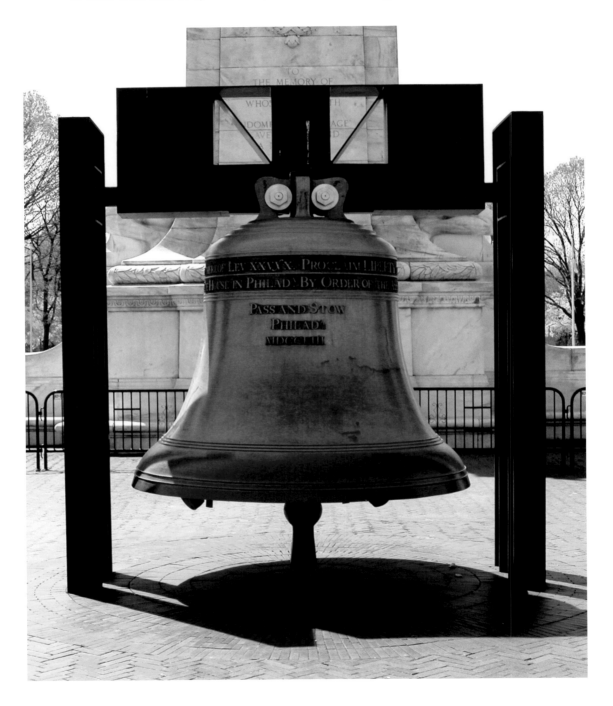

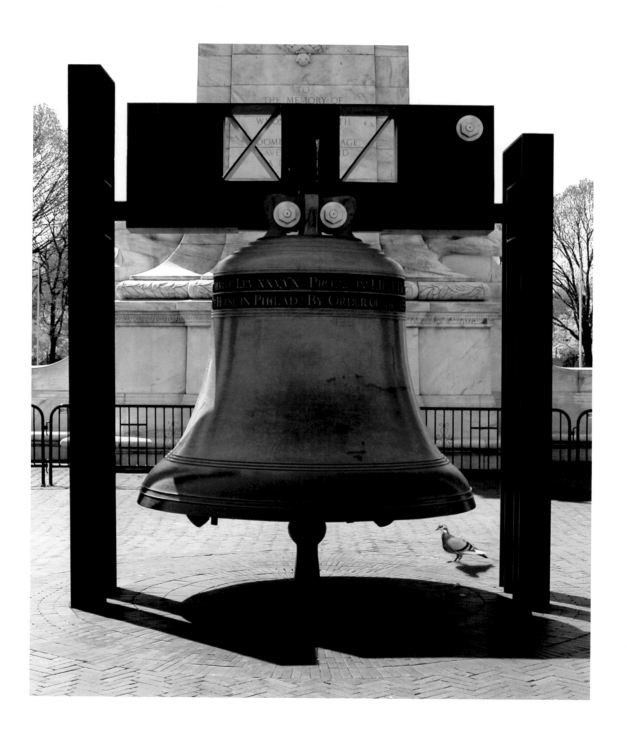

CAPITOL IDEAS

Washington may be known for its fat cats, but this building is "rotunda."

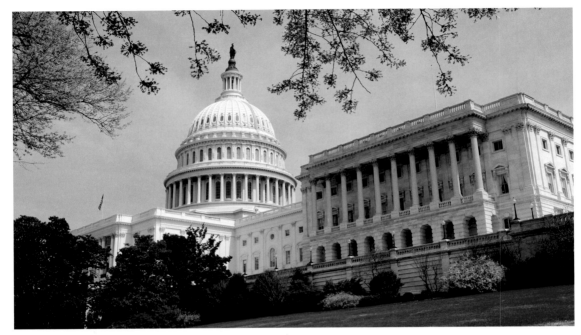

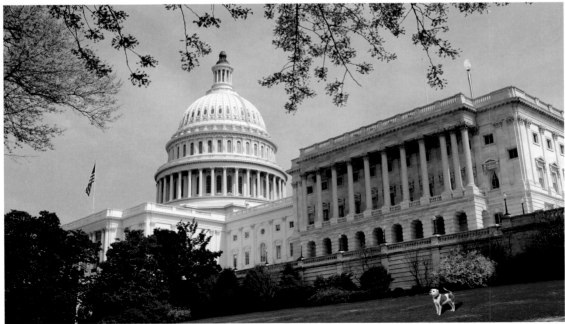

7 Changes

CRUISE CONTROL

The Port of Miami is called "Cruise Capital of the World" for the number of ships sailing in and out. Chart a course out of this conundrum.

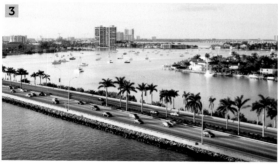

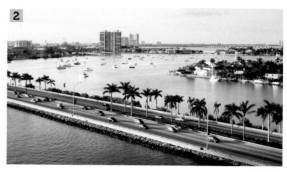

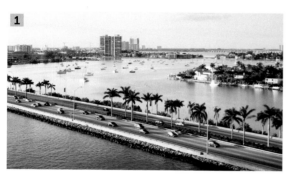

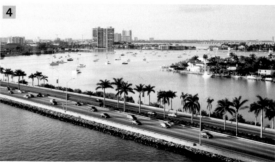

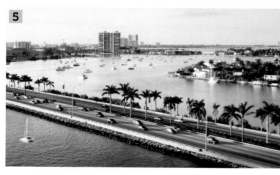

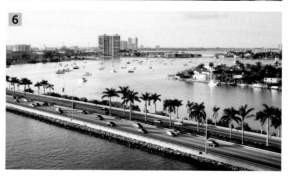

SOARING AND SCORING

Is it us, or is this bald eagle losing a few feathers on top?

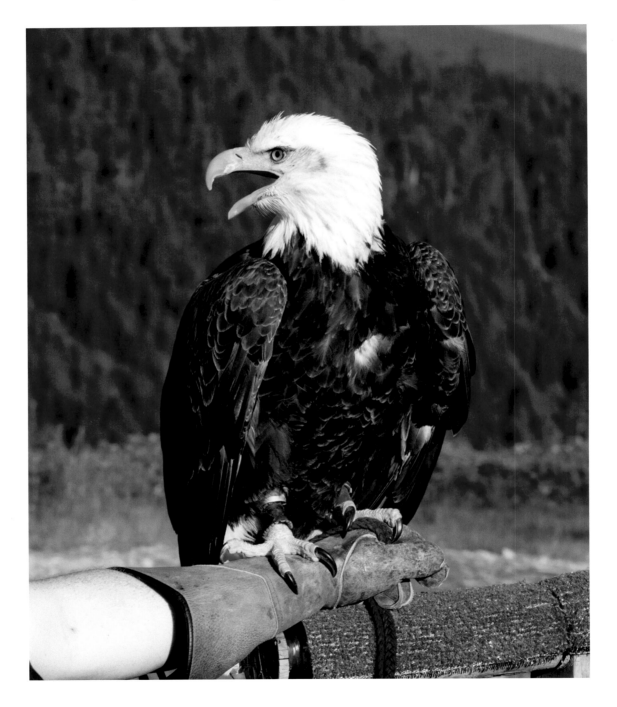

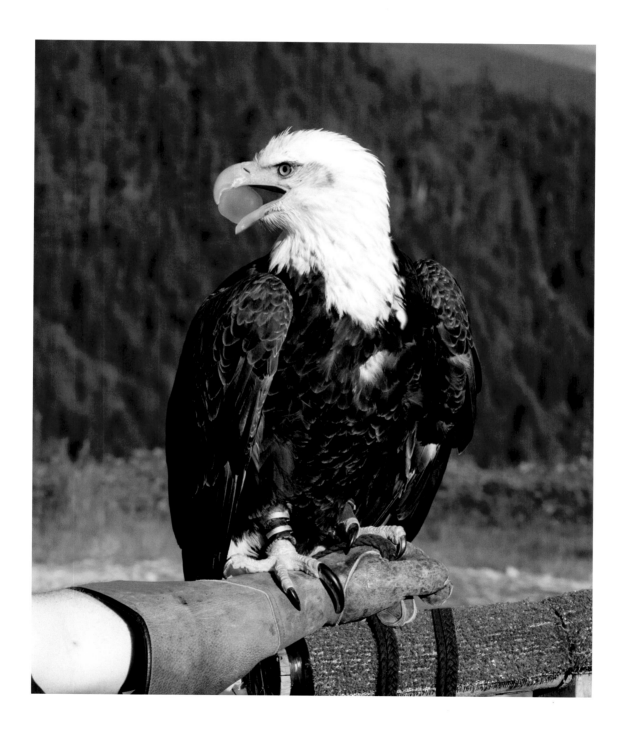

OASIS IN THE CITY

Downtown Orlando's Lake Eola is gushing with activity.
Take what the locals call a "buena vista"—a good look.

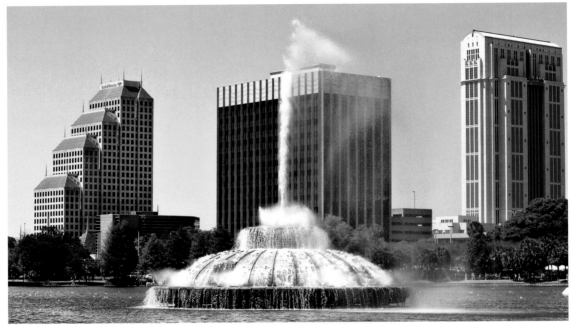

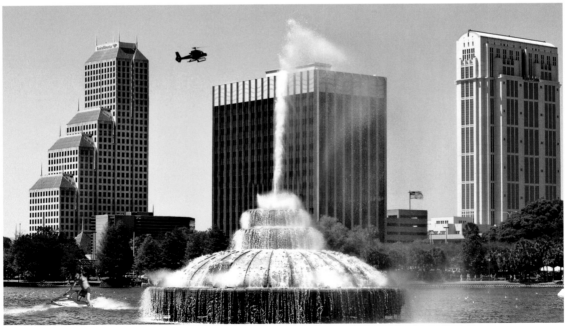

○○○○○○○ 7 Changes

DOCK OF THE BAY

The Embarcadero's colorful history recalls a San Francisco of days gone by.
How's your recall?

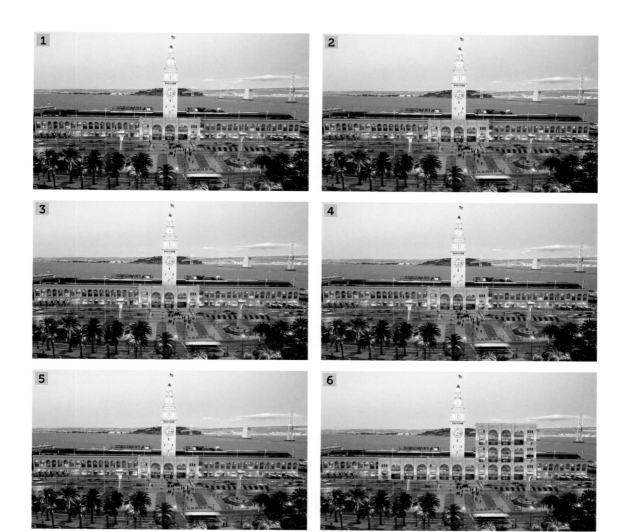

BROADWAY BOUND

They say the lights are bright here. See for yourself.

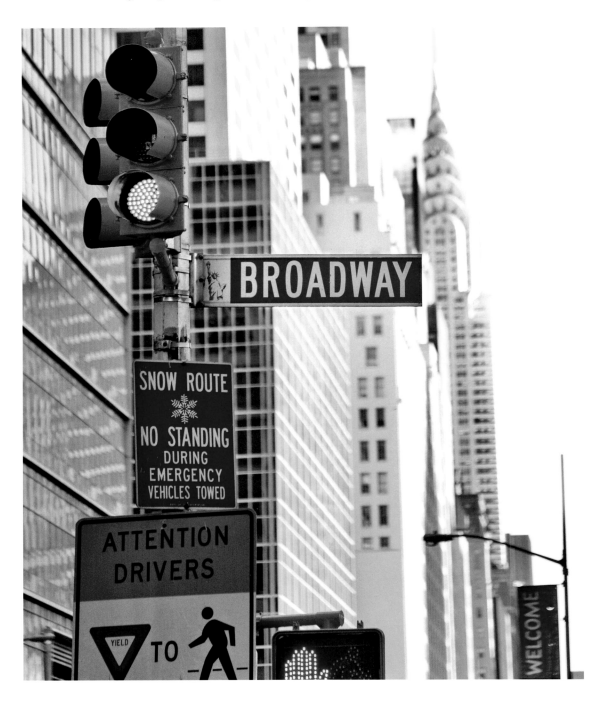

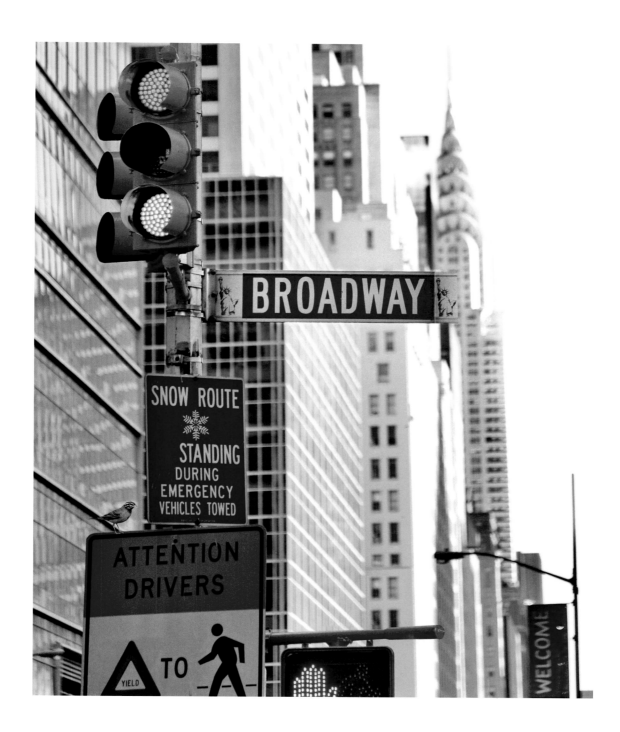

VIEW FROM THE TOP

As seen from Navy Pier's giant Ferris wheel, Chicago occupies a dramatic sweep of Lake Michigan.

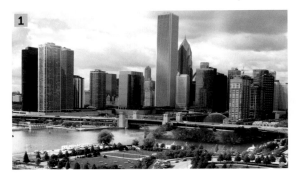

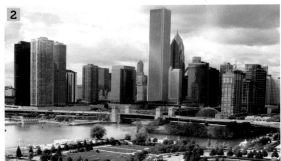

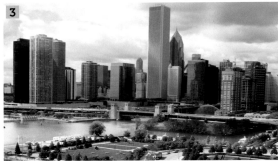

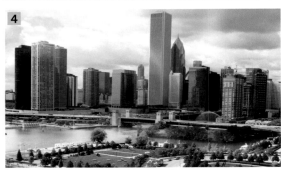

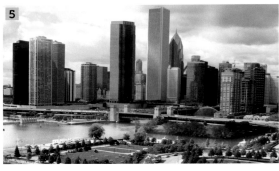

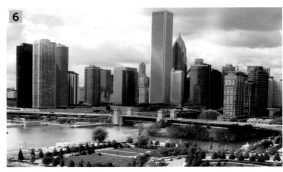

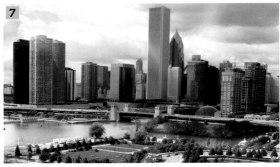

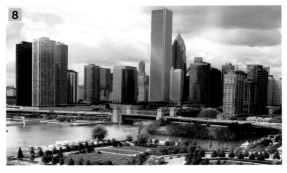

MONUMENTAL OVERSIGHT

Thomas Jefferson held some truths to be self-evident.
For the rest you'll have to squint.

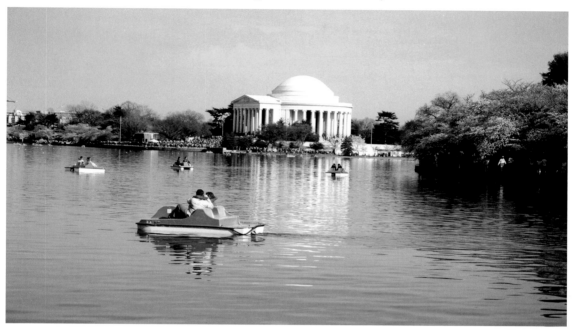

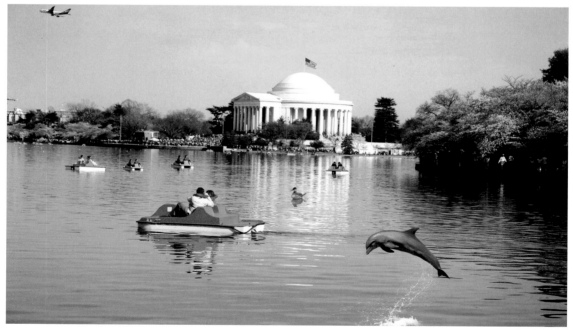

SOCK 'EM

With the goalkeeper out of net, it looks like an easy kick.
Take your best shot at this puzzle.

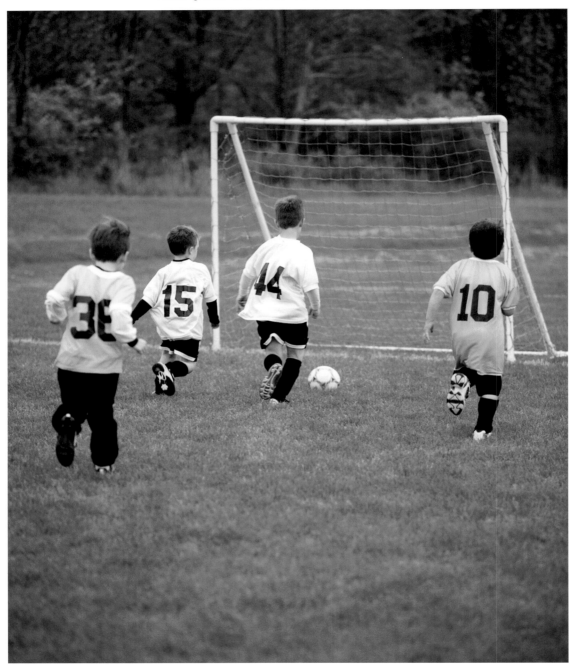

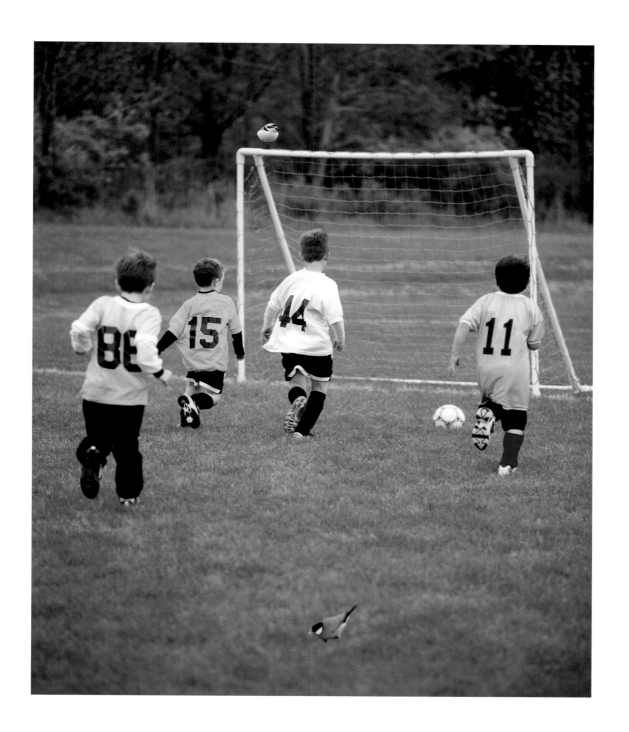

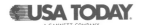

TEE FOR TWO

It's time for tee-off. Care to join? Find the 8 holes in this course.

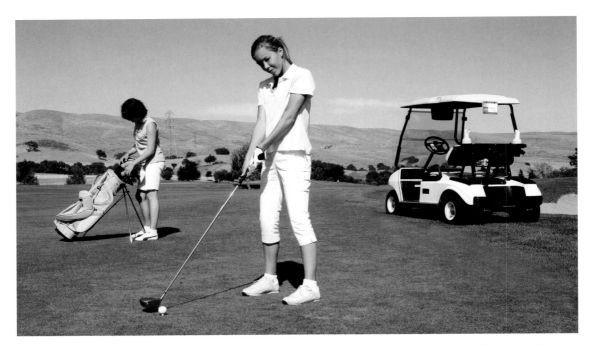

◯◯◯◯◯◯◯◯ 8 Changes

BONDING IN THE BULLPEN

That's what these li'l pitchers are doing to warm up for the big game.
You pick the reliever.

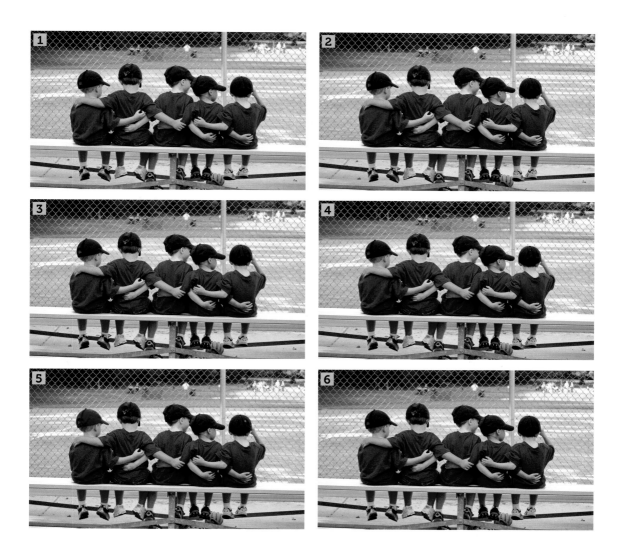

COURSE CORRECTION

Golf is a game for all generations to play together. Which photo has descended to a new generation?

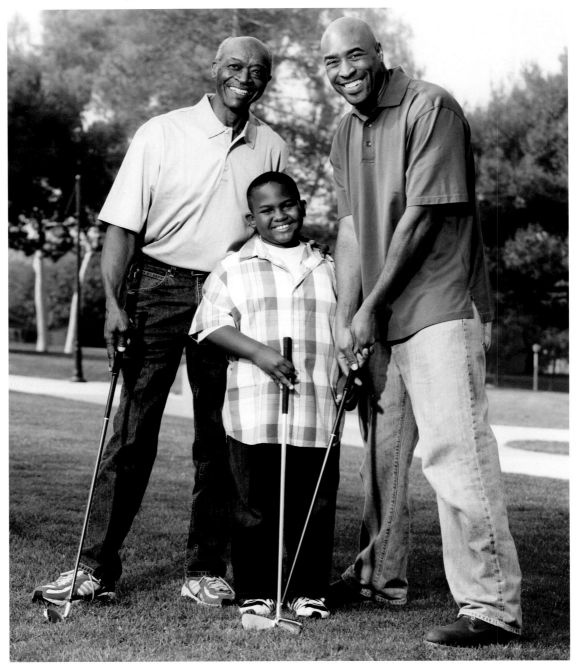

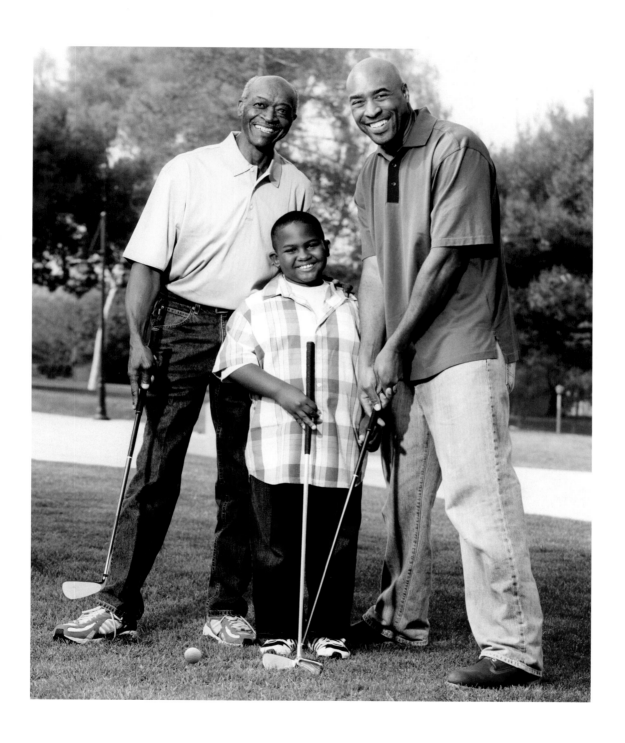

7 Changes ⬡⬡⬡⬡⬡⬡⬡

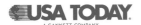

BATHING BUFFET

Alaskan grizzlies always order salmon, then wait for dinner to swim upstream.

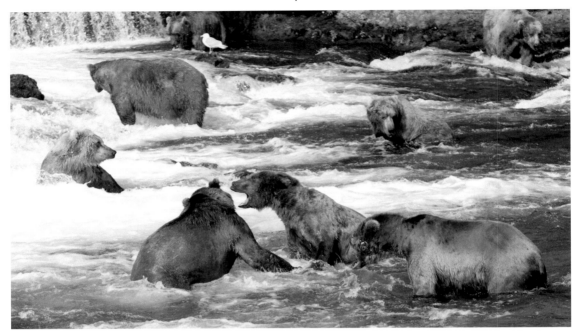

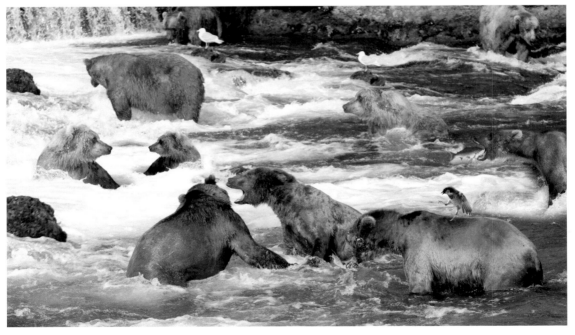

7 Changes

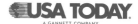

THE YOUTH CLUB

This foursome looks a little green and rough around the edges.
Make sure they're playing the fair way.

A SWING AND A ...

Can you spot the differences right off the bat?

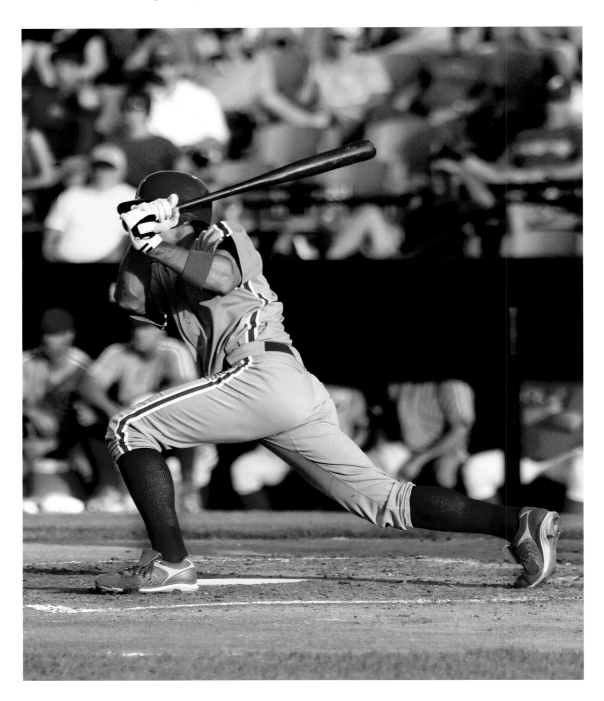

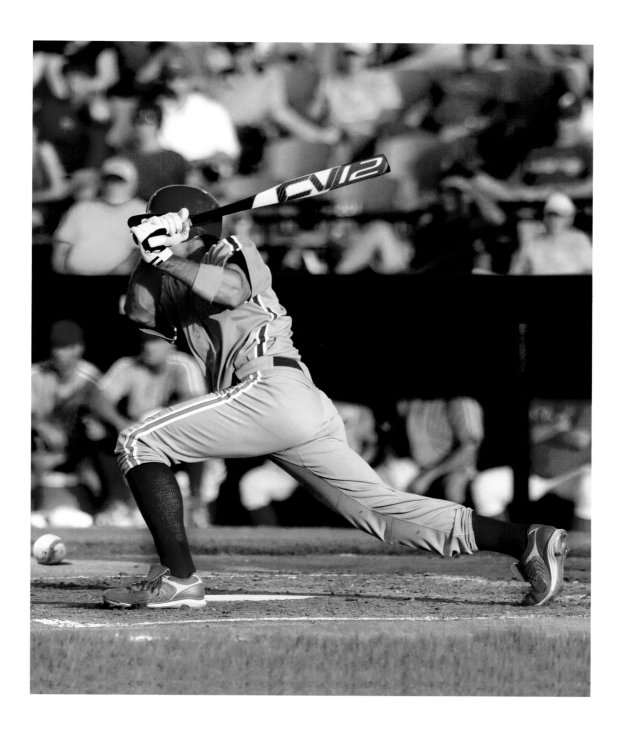

THERMAL UNDER WHERE?

The Valley of Geysers is a great place to blow off steam.

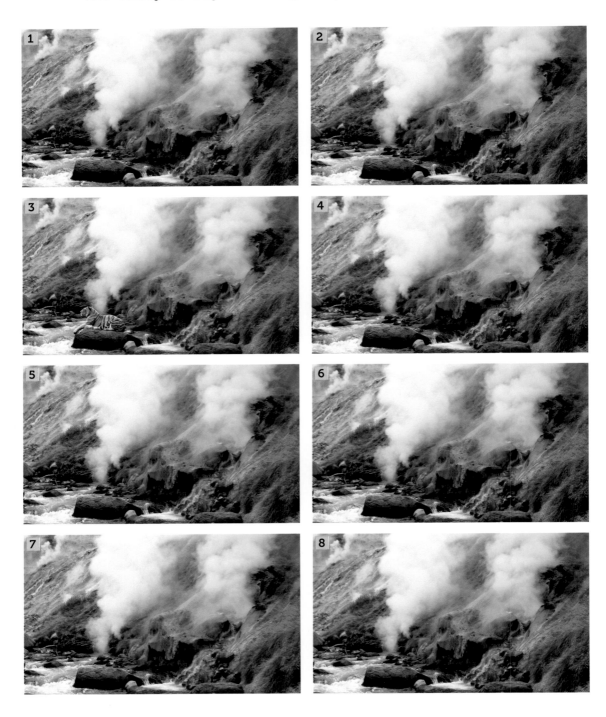

PARADISE

Meadows flush with wildflowers and ringed with snowcapped mountains, make for an almost pristine picture.

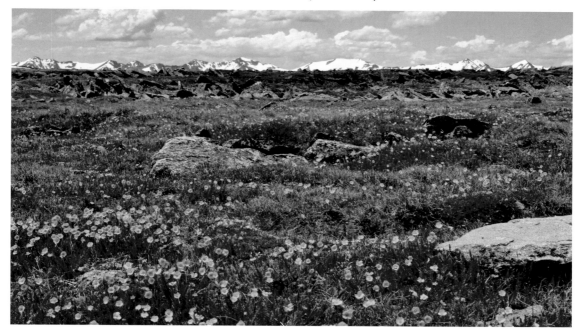

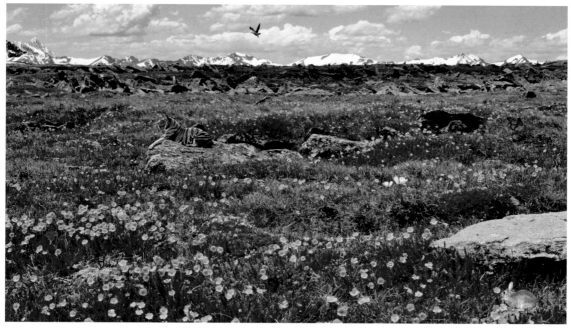

8 Changes ⬡⬡⬡⬡⬡⬡⬡⬡

SUNSHINE STATE OF MIND

Florida's Sunshine Skyway is the world's longest cable-stayed concrete bridge, with 21 steel cables. We've added 7 roadblocks to watch out for.

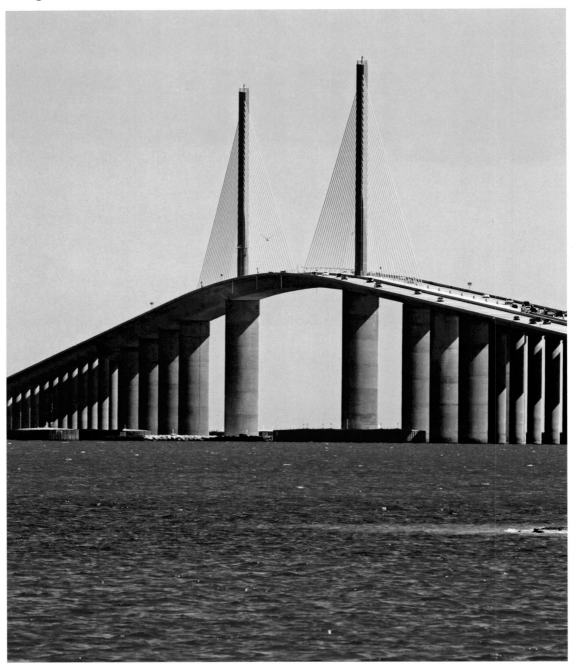

USA TODAY
A GANNETT COMPANY

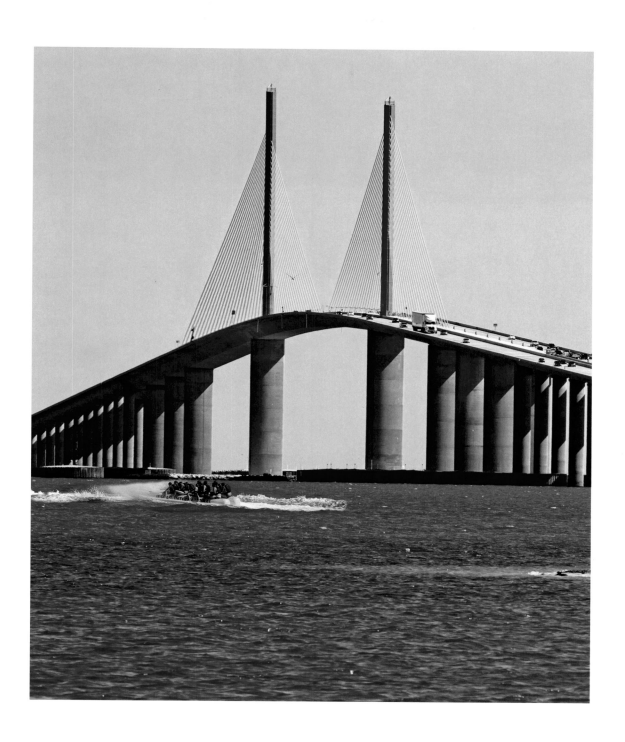

NESTING INSTINCT

Secluded though this hideaway may be, unexpected visitors do drop in.
Greet all 5.

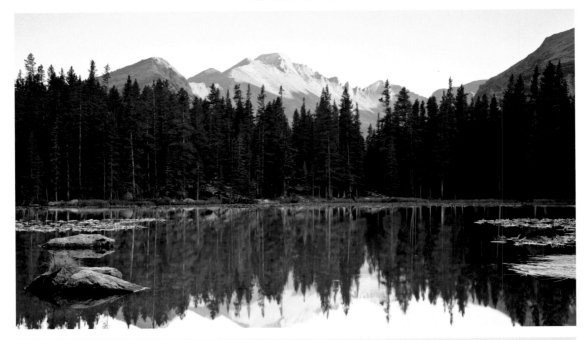

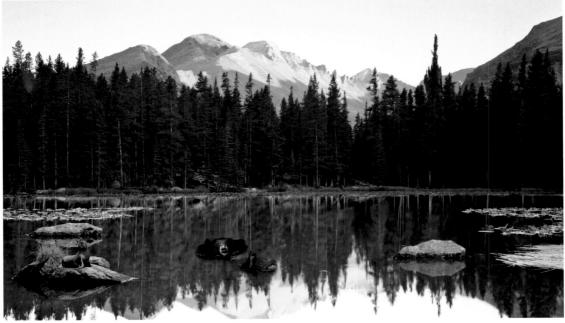

5 Changes

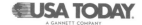

THE HIGH ROAD

The views from these mountain peaks are sure to get a rise out of you.

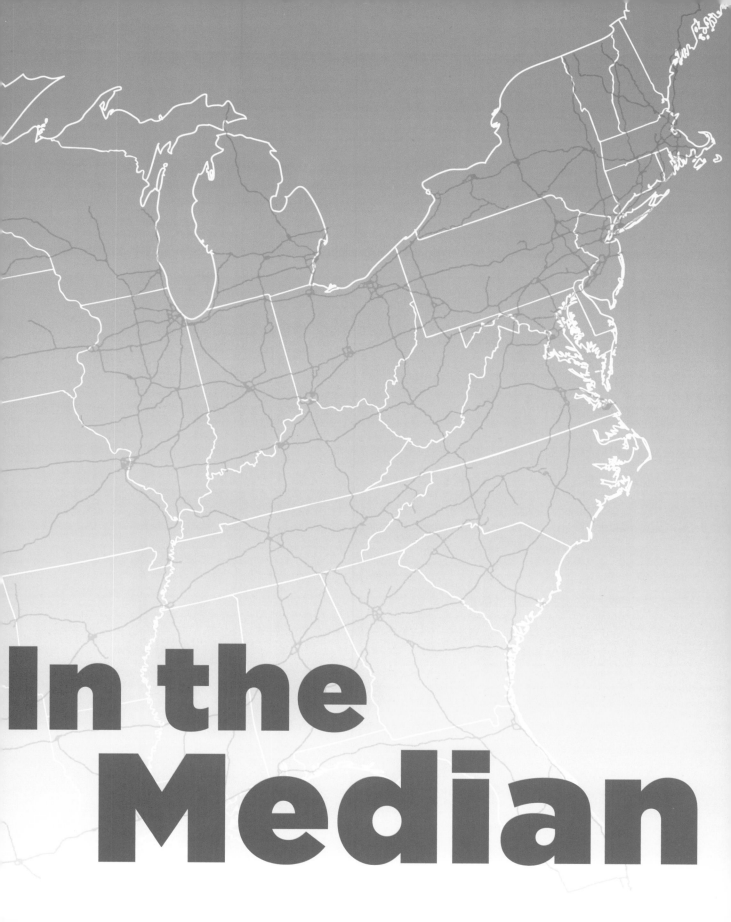

In the Median

COLOR GUARD

The changing of the guard is a ritual at Arlington National Cemetery. Make sure everyone is marching to the same tune.

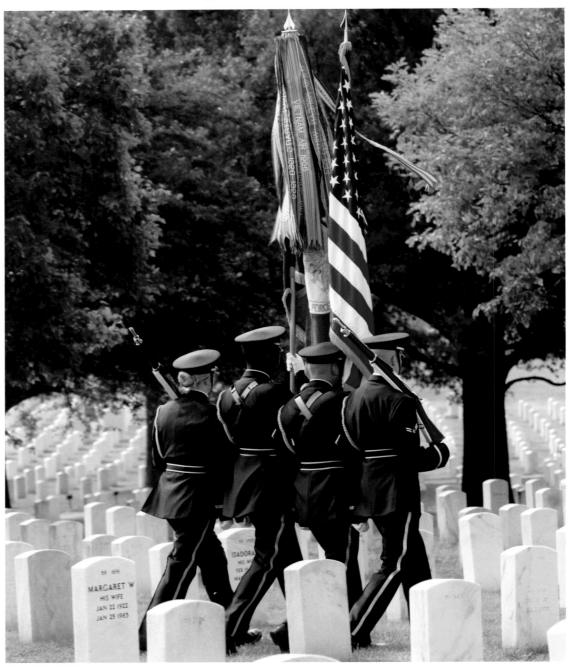

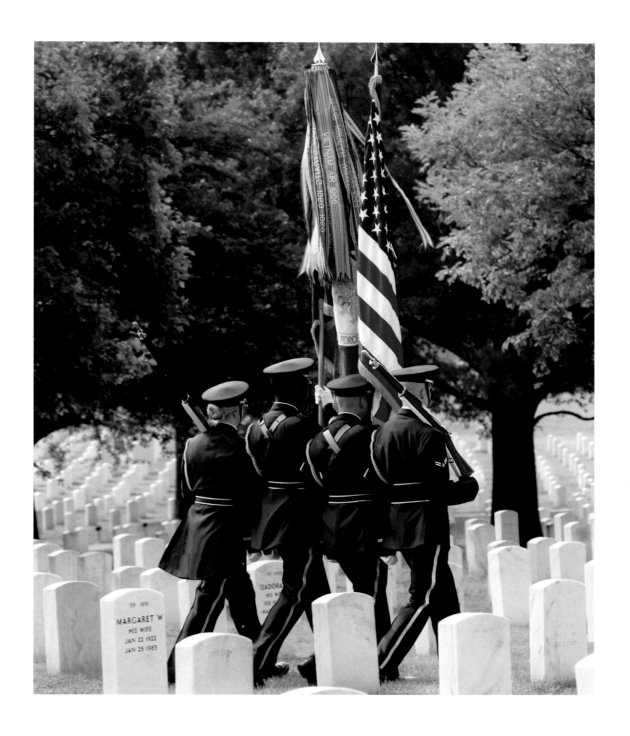

NOEL-LUSION

Unwrap this Christmas riddle.

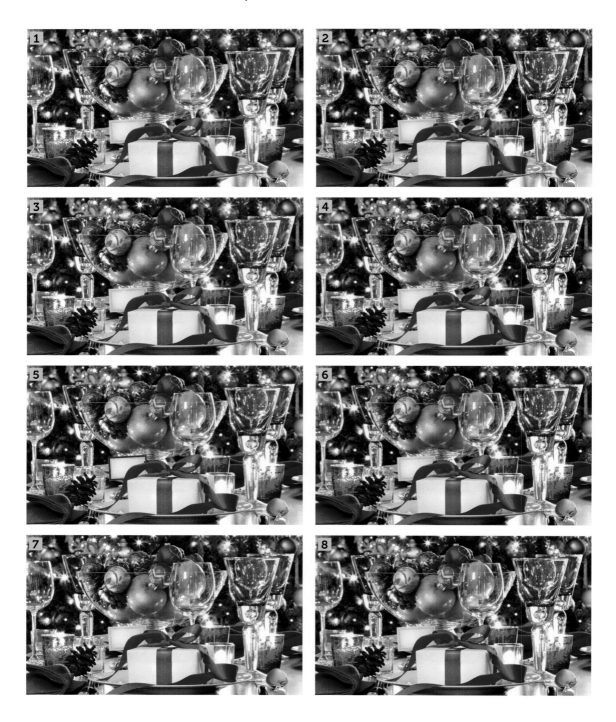

EAT YOUR GREENS

Food coloring isn't the only thing a wee bit funny about these St. Patrick's Day treats.

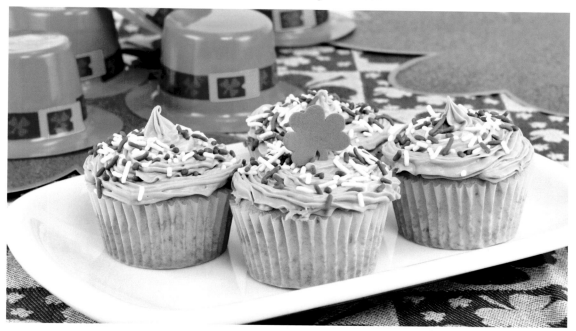

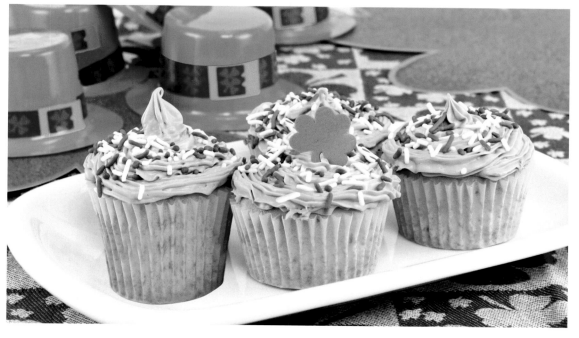

7 Changes ⬡⬡⬡⬡⬡⬡⬡

MOUNTAIN MEN

Rush more to spot 5 "un-presidented" changes we made to this American icon.

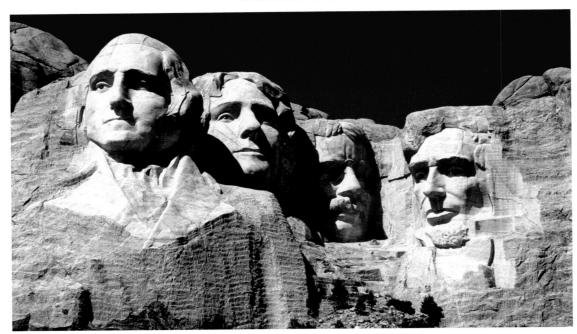

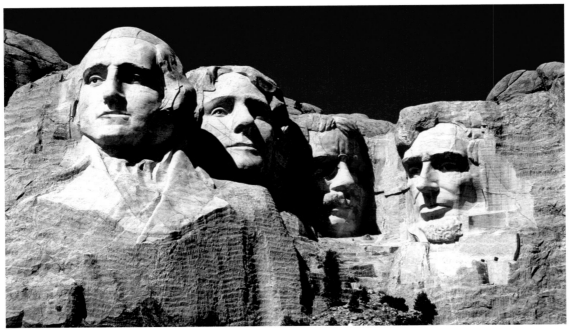

5 Changes

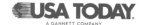

SALT LAKE CITADEL

The Utah State Capitol's ornate interiors never fail to a-maze visitors.

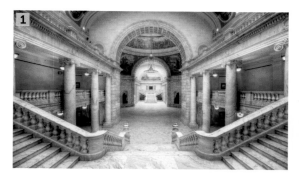

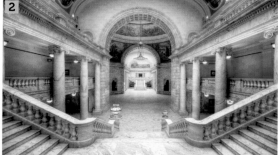

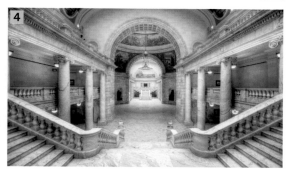

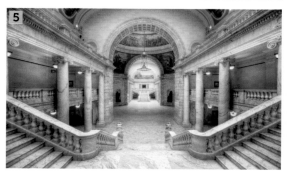

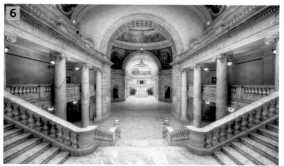

A BEACON OF HOPE

A gift from France, Lady Liberty stands fast in New York Harbor.
Shine a light on this picture and catch 6 changes.

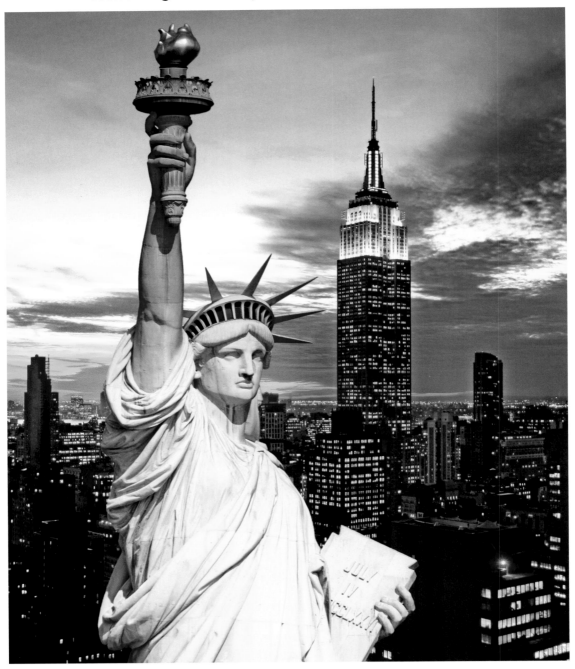

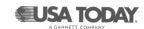

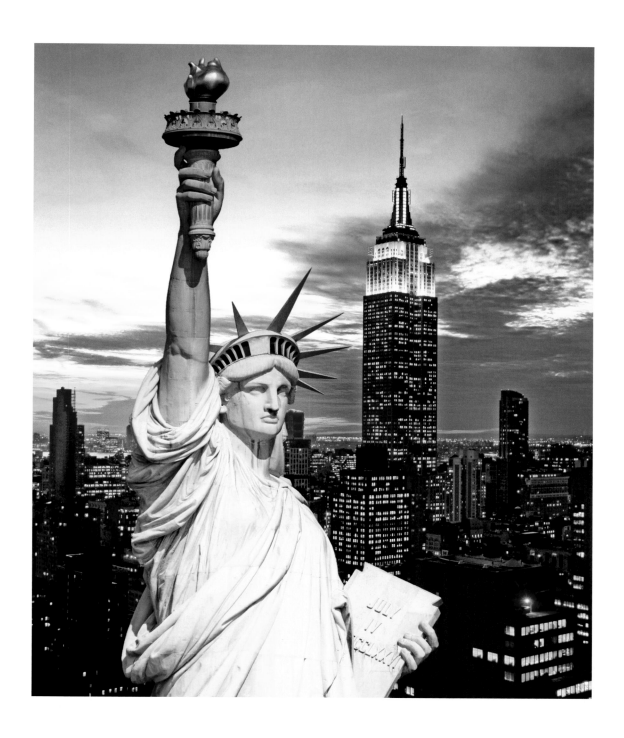

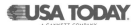

EVEN WITHOUT A FOOD COURT

The National Mall in Washington, D.C., attracts approximately 24 million visitors every year.

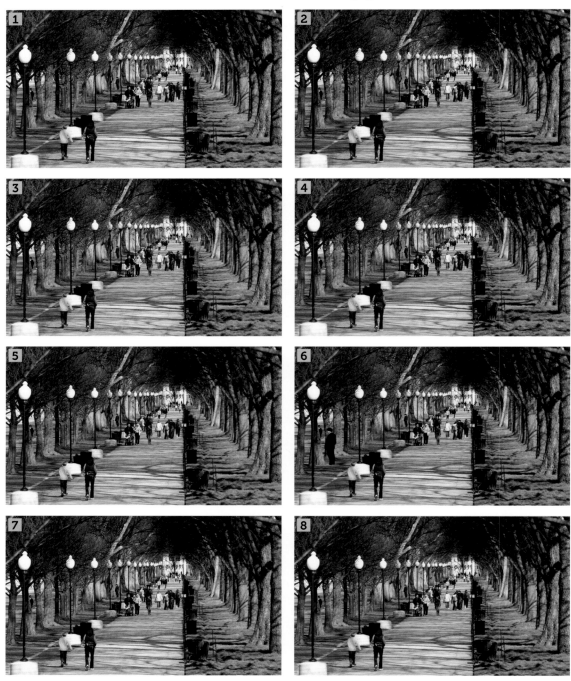

PULL!

Several of Harvard University's residential halls are lined up in a "row" along the Charles River. Think fast before you sail past.

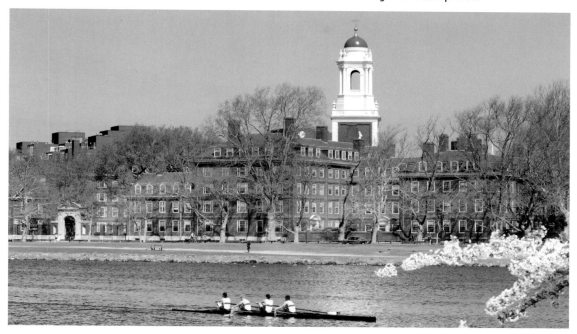

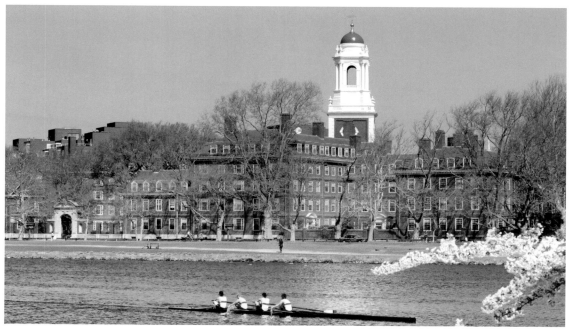

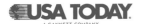

WITH HONORS

Memorial Hall is a standing reminder of Harvard grads who fought for the Union in the Civil War. Now let's see how smart you are.

1
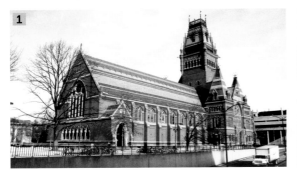

2
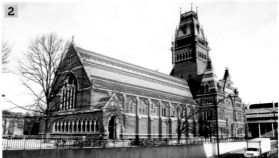

3

4
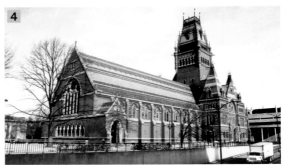

5
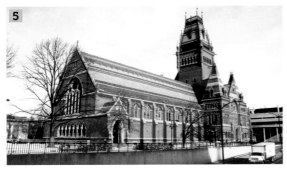

6
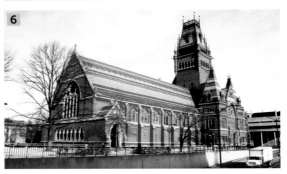

7
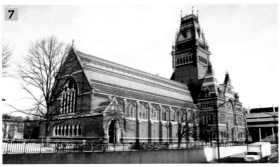

8
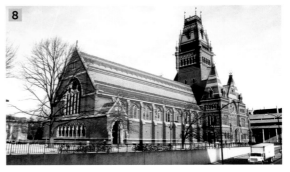

SMELLS FISHY

Virtually overnight, the Gold Rush created San Francisco out of a fishing village. Coming up: another quick change.

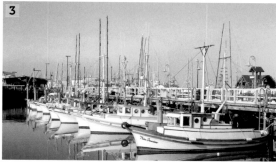

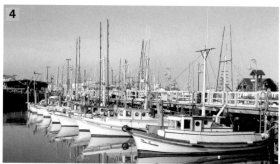

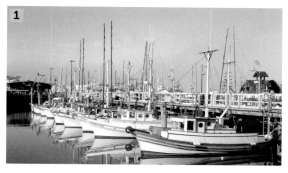

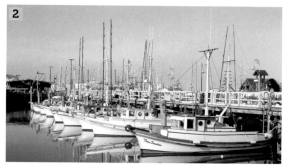

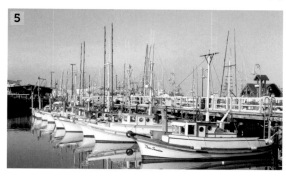

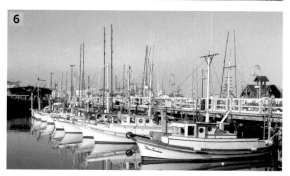

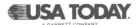

START SPREADING THE NEWS

No, they didn't move the Statue of Liberty—Las Vegas decided to build its own. What else doesn't belong?

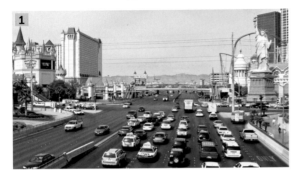

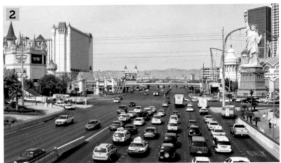

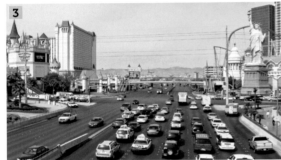

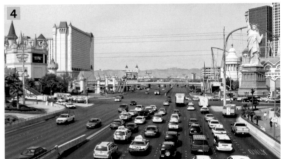

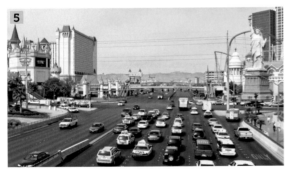

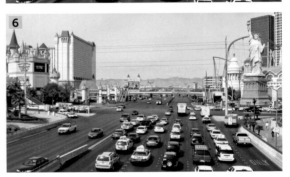

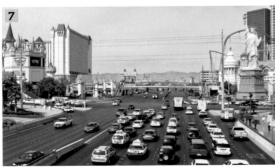

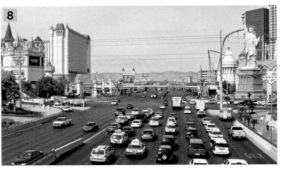

RETRO REVIVAL

A new Art Deco luxury hotel reflects the breezy, seaside character of Miami architecture, but a few details don't blend in.

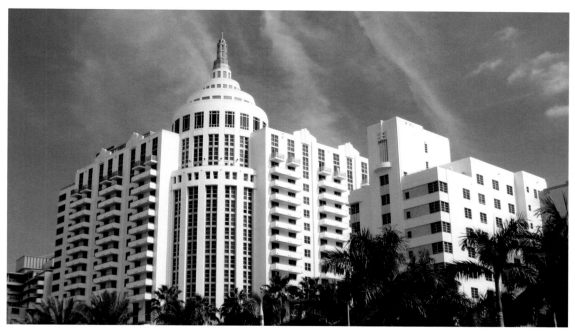

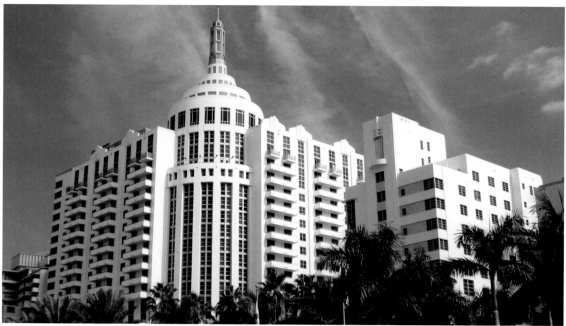

HANGING AROUND

This building overlooks Boston Common, where witches and pirates were once led to the gallows. Eek!

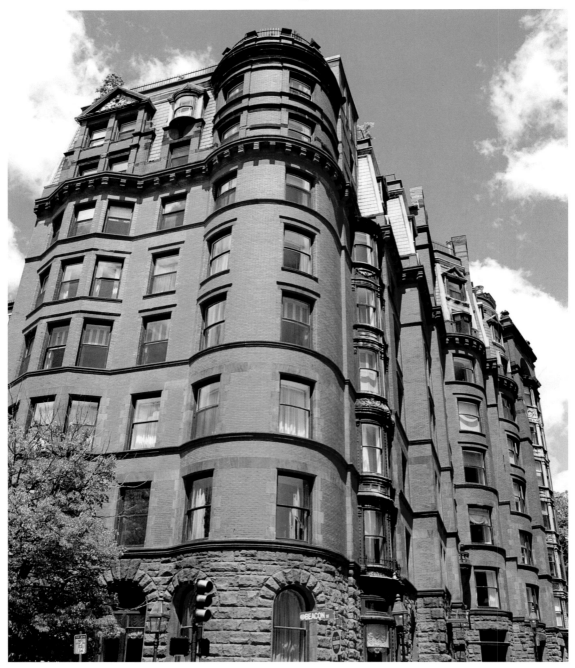

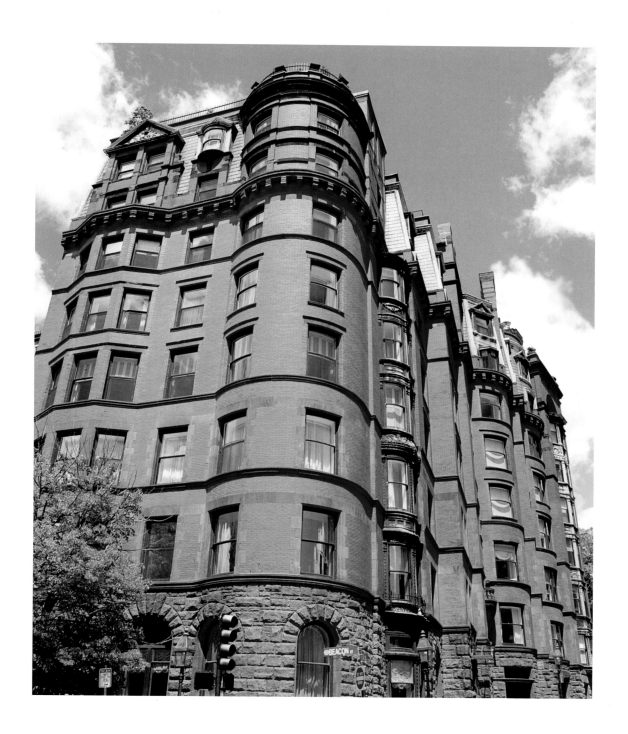

BRIDGE TO KNOW WHERE?

Sunset brings out the lights of the Brooklyn Bridge and Lower Manhattan.
"You got a problem wit dat?"

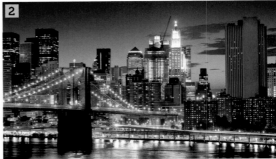

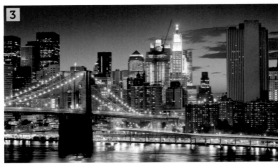

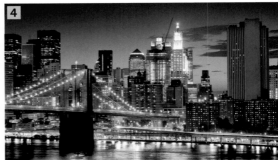

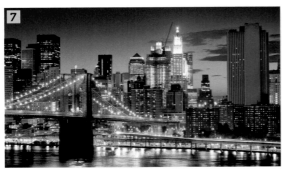

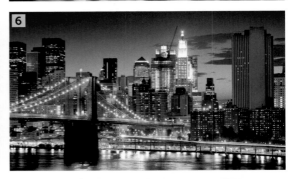

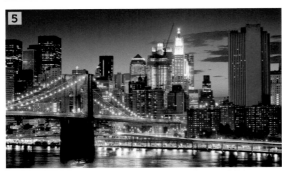

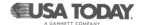

POSTCARD ROW

These Victorian-style homes across Alamo Square Park are famously known as the "Painted Ladies." Do they need a fresh coat?

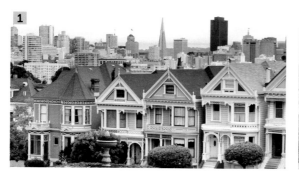

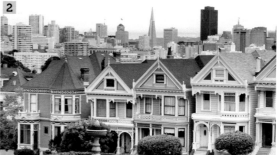

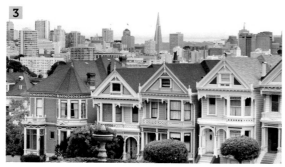

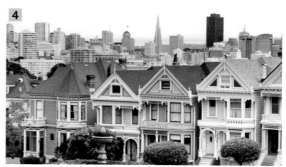

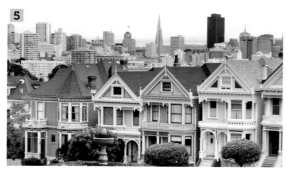

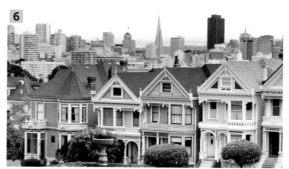

GO OVERBOARD

Though Chicago owes the "windy" moniker to its politicians, not its weather, Navy Pier will leave you hanging in the breeze.

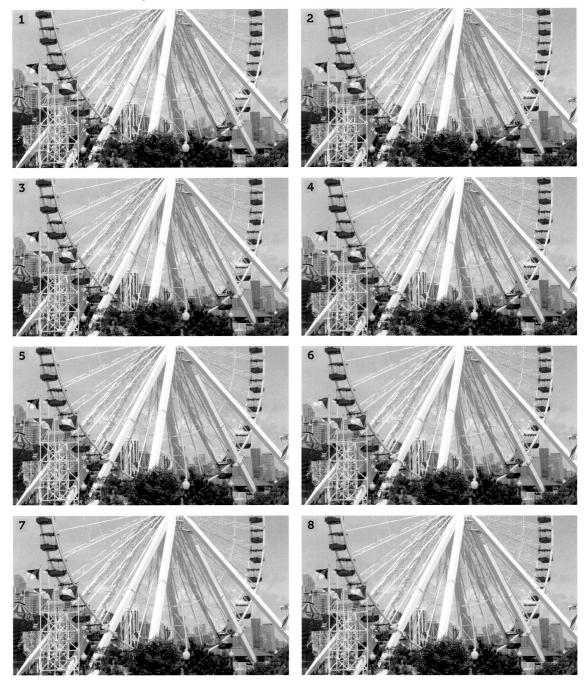

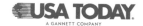

ROCK SOLID

These precarious looking rock formations have been in place for millennia.
Still, you may notice some shifting.

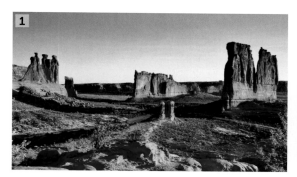

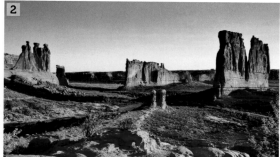

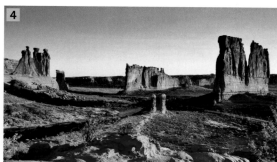

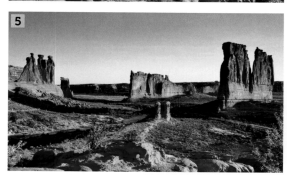

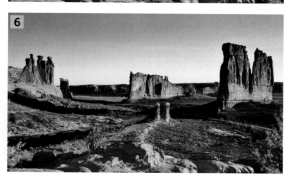

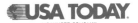

A QUIET OASIS

Boston's upscale Back Bay neighborhood is dominated by stately Victorian brownstones. Do they all look the same?

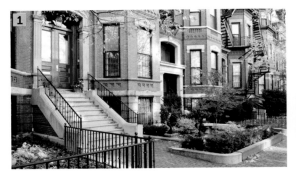

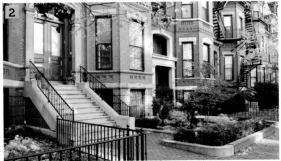

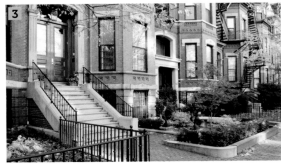

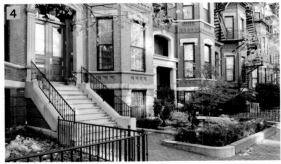

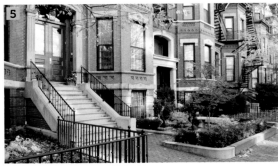

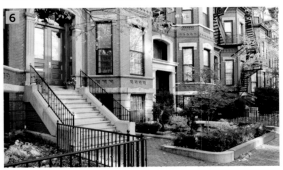

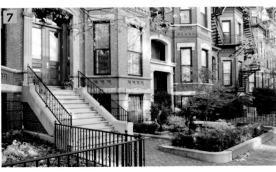

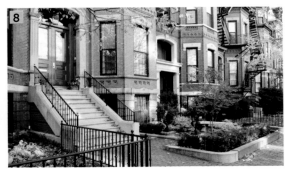

TIME OUT

While the coach draws up X's and O's on the sideline, things are playing out differently on the court.

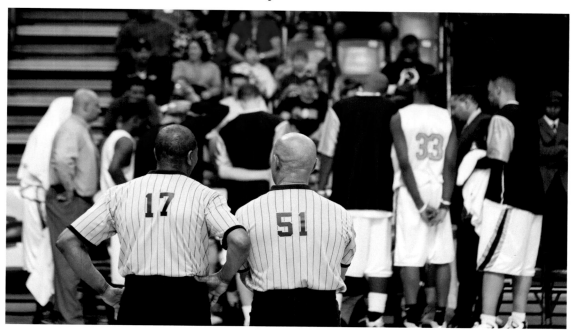

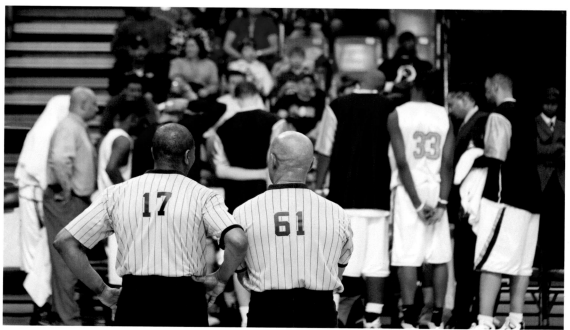

7 Changes ◯ ⬡ ⬡ ⬡ ⬡ ⬡ ⬡

TAKE ME OUT

Enjoy the sights, sounds and subtly switched specifics of the ballpark.

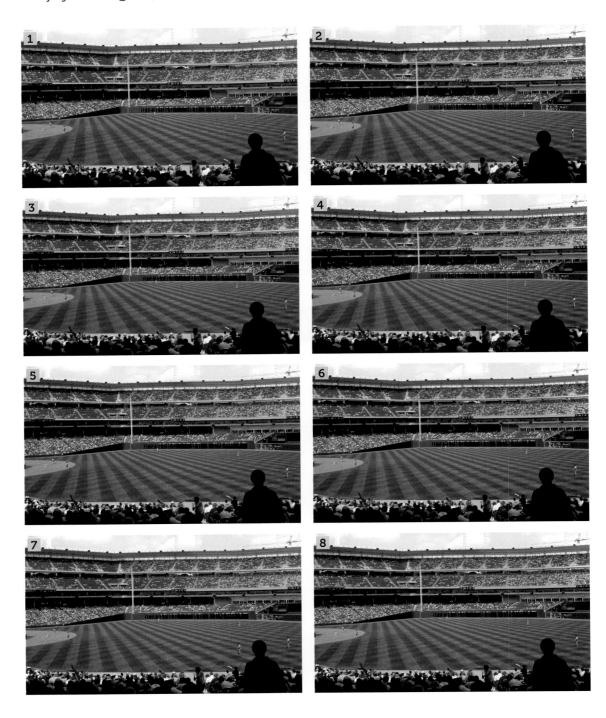

BRINGING THE PAST TO LIFE

What do you get when you cross New England's colonial past with a mall?
Quincy Market, plus a few remainders.

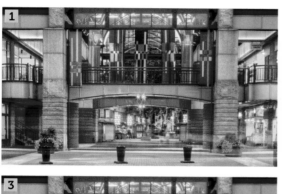

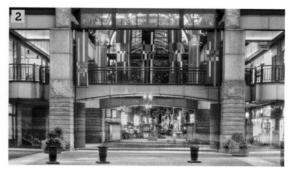

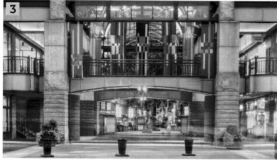

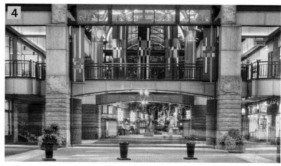

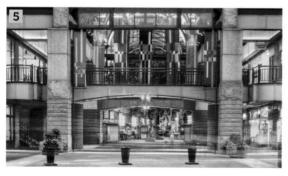

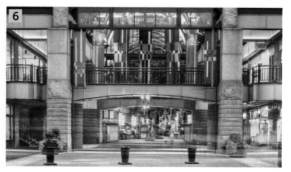

OH, SAY, CAN YOU SEE?

These Pro Bowlers pay homage to the nation before battling it out on the gridiron.

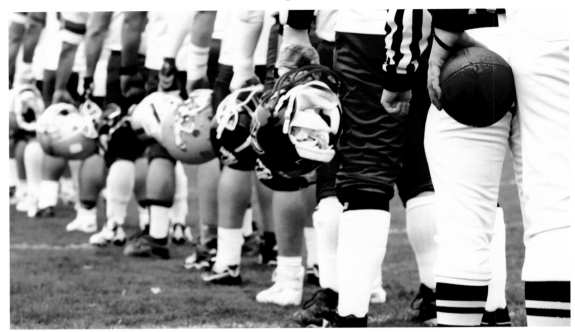

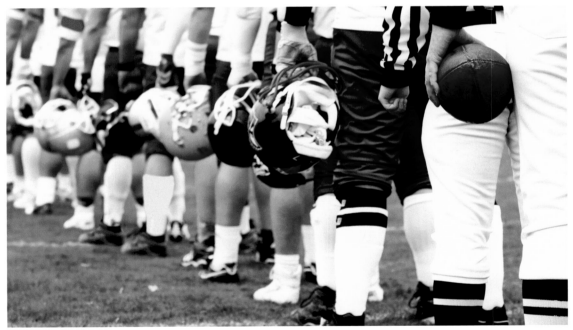

7 Changes

LITTLE LEAGUE CHAMPS

It seems these young players are really hitting it off. Batter up!

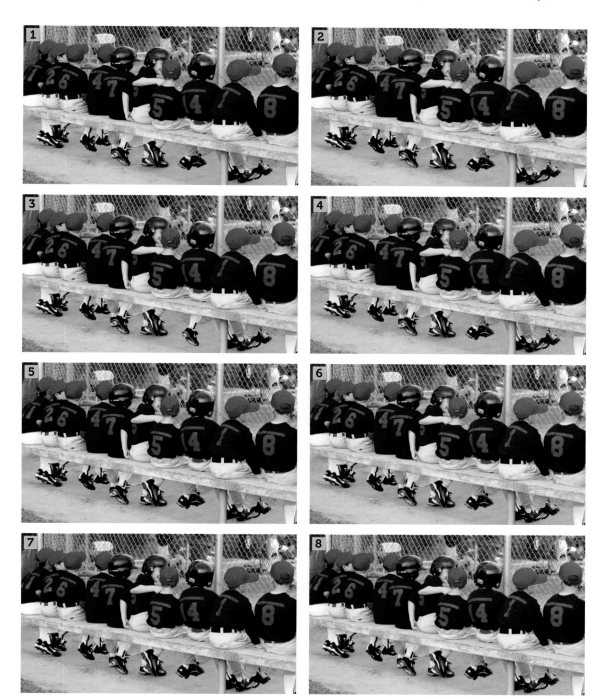

SPANISH (STYLE) INQUISITION

¡Cómo es hermoso! This tower stands in San Diego's Balboa Park.

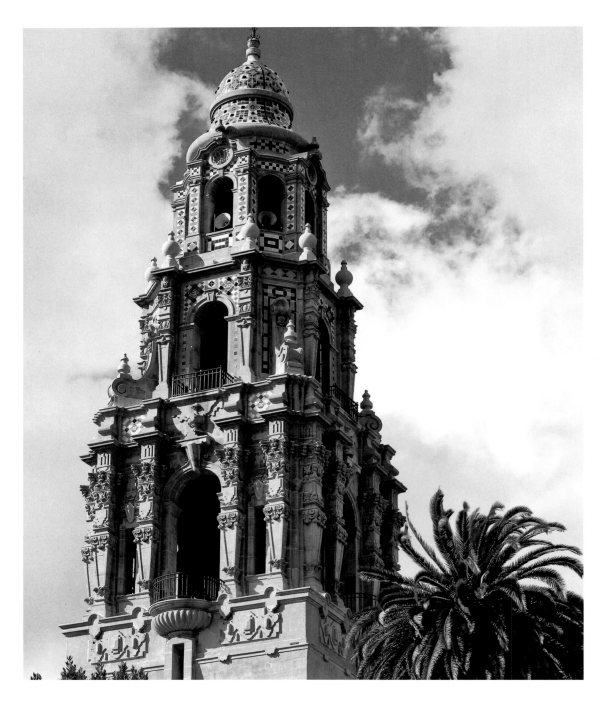

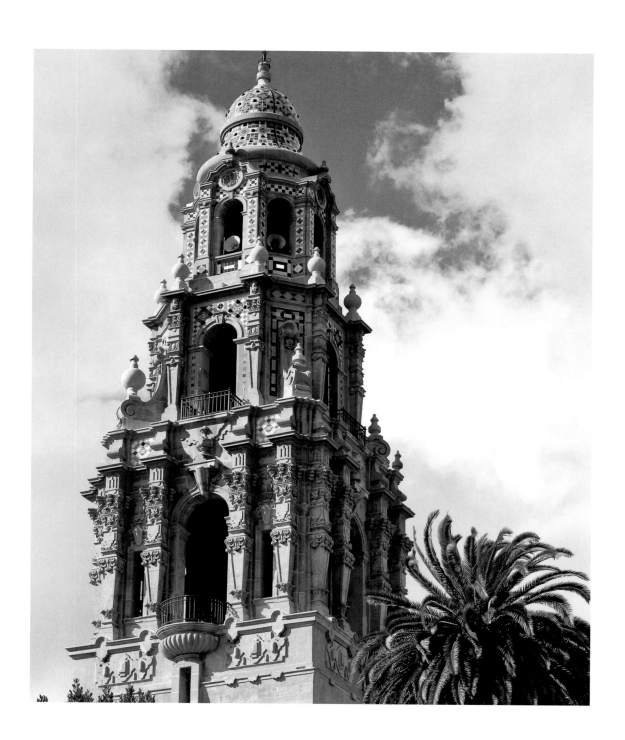

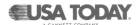

MITT CONDITION

Play ball! This glove won't break itself in. Or will it?

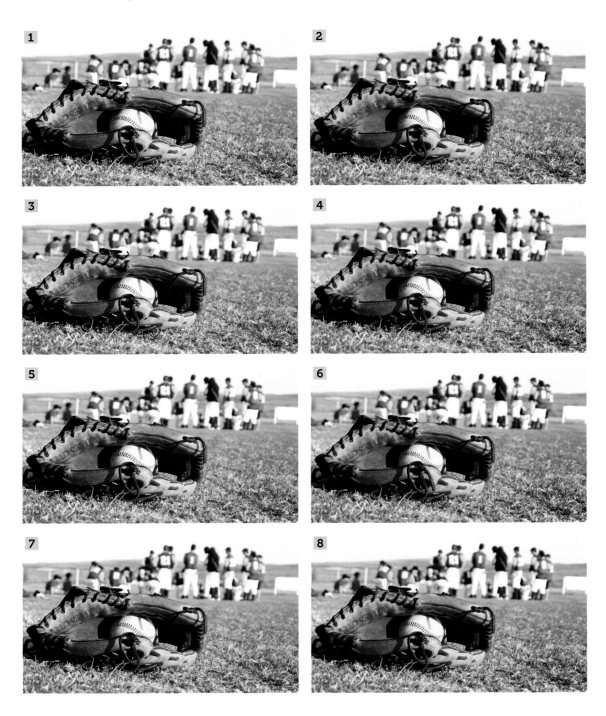

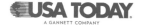

DESERT ROSE

Sedona, Arizona, is known for its majestic red sandstone formations that glow a brilliant orange or red when illuminated by the sun.

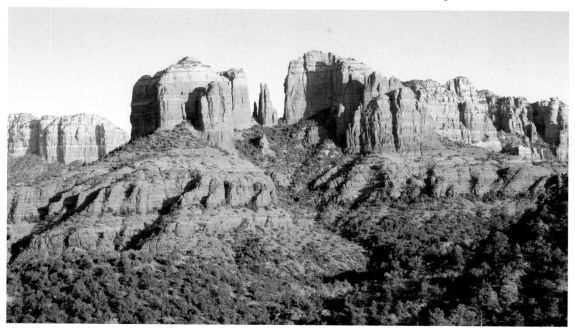

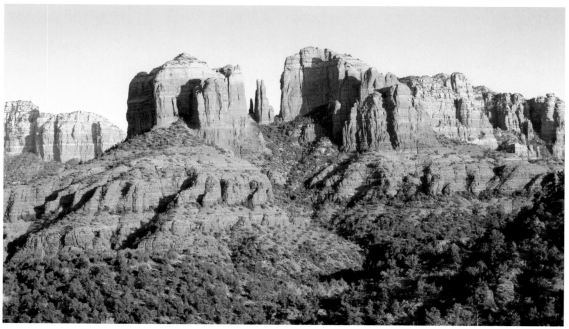

MAKE THE GRADE

San Francisco's Lombard Street was created with sharp curves to prevent people rolling down its steep slope. Look out!

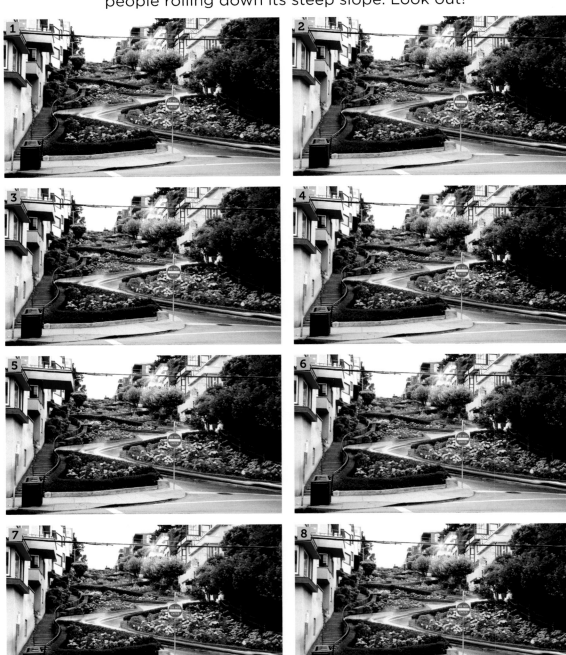

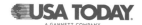

BEARLY MOVING

Here's one grizzly in Juneau, Alaska, you can give a bear hug.

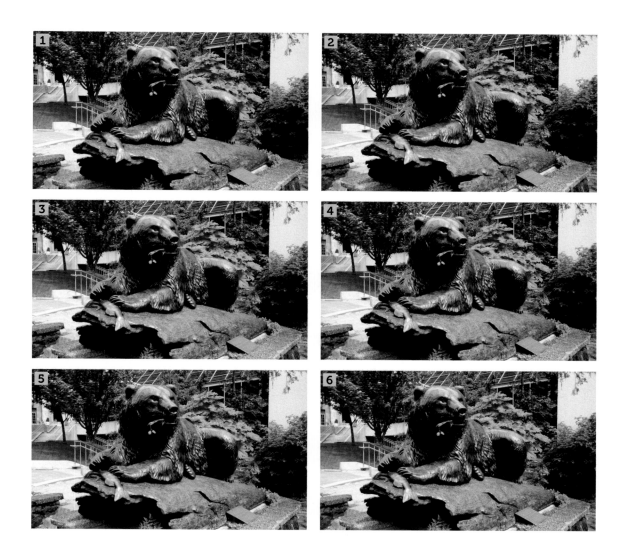

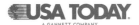

"FEET" OF NATURE

The Grand Canyon, one of nature's most awe-inspiring creations, is a product of erosion. We've sped up the process.

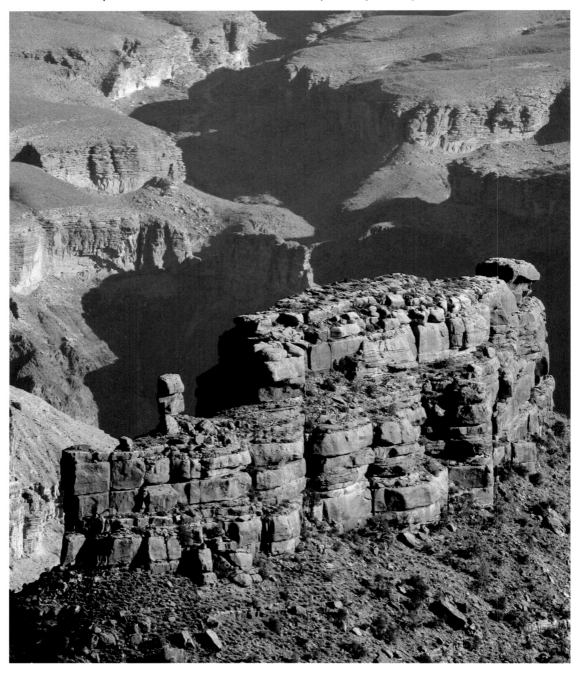

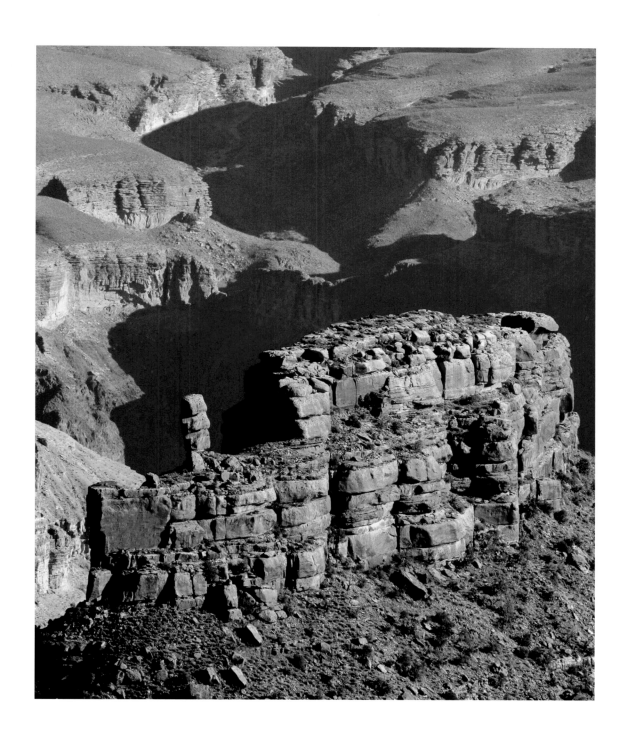

SUNBATHING

Sea lions have taken over the marina at San Francisco's Pier 39.
"Sea" anything wrong with that?

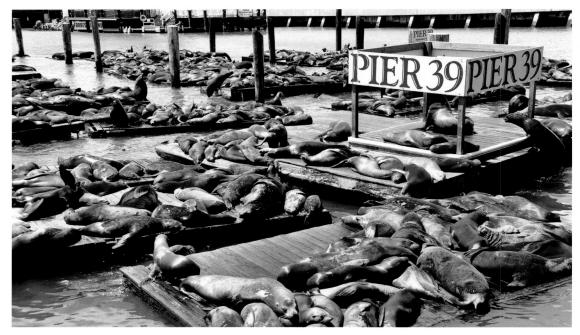

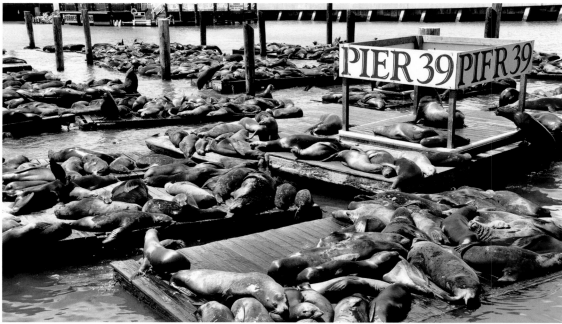

7 Changes

HORNSWOGGLED

At Yellowstone National Park, you're guaranteed to sight herds of bighorn sheep. Just make sure you don't ram any.

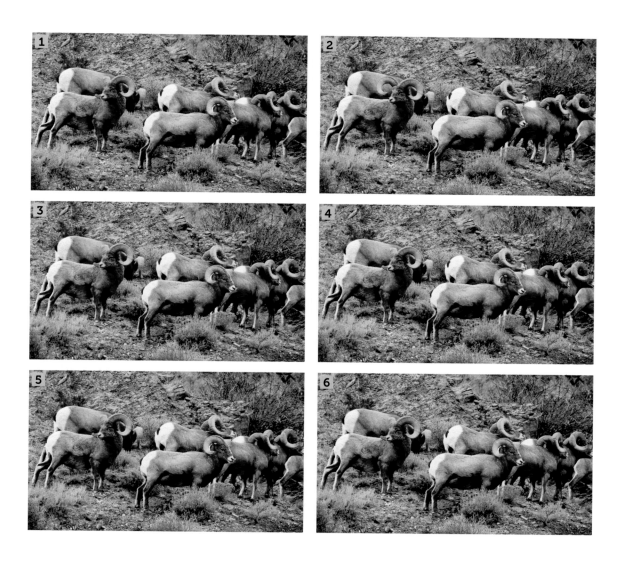

MILE-HIGH MYSTERY

Breathtaking moments and countless adventures await those who visit the Rocky Mountains.

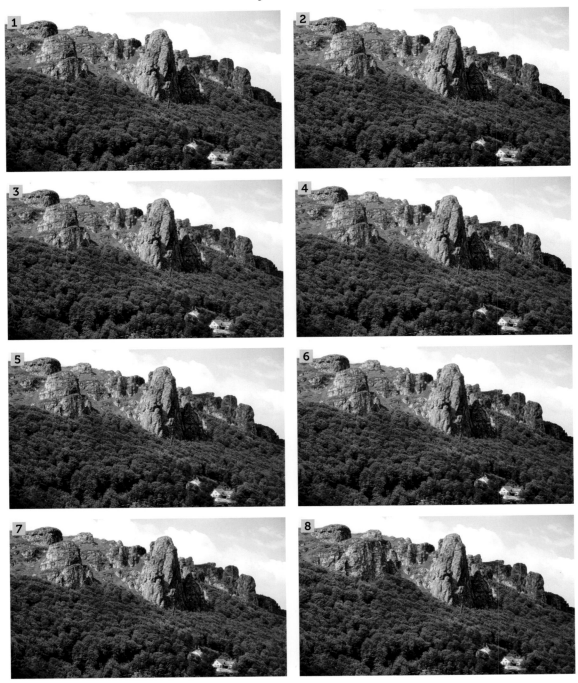

DON'T FALL FOR IT

The Maid of the Mist sails perilously close to Horseshoe Falls to give visitors a chance to experience Niagara Falls' jaw-dropping immensity.

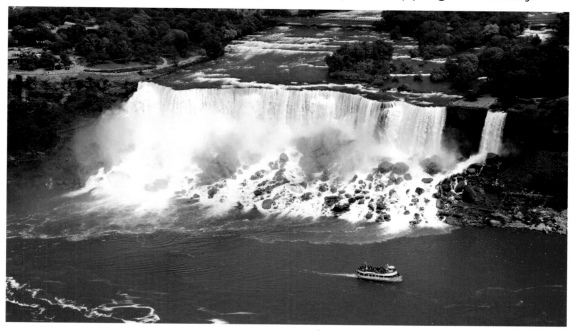

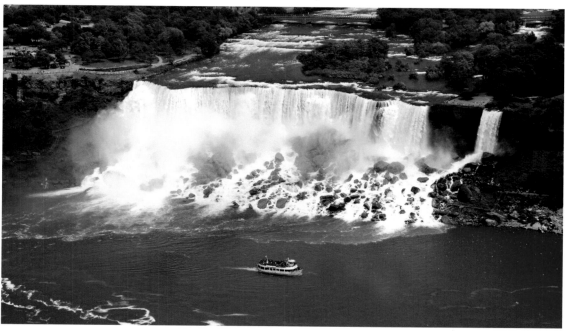

6 Changes ⬡⬡⬡⬡⬡⬡

ESCAPE TO ALCATRAZ

Once home to the most notorious criminals, Alcatraz today draws tourists looking for a taste of history.

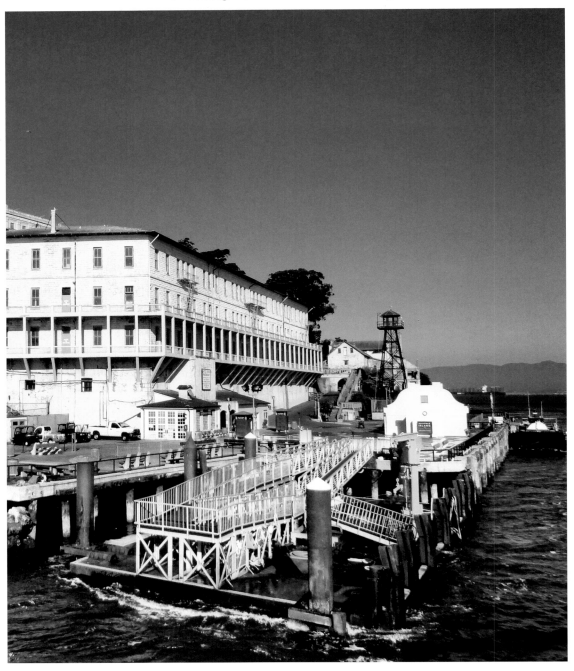

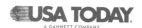

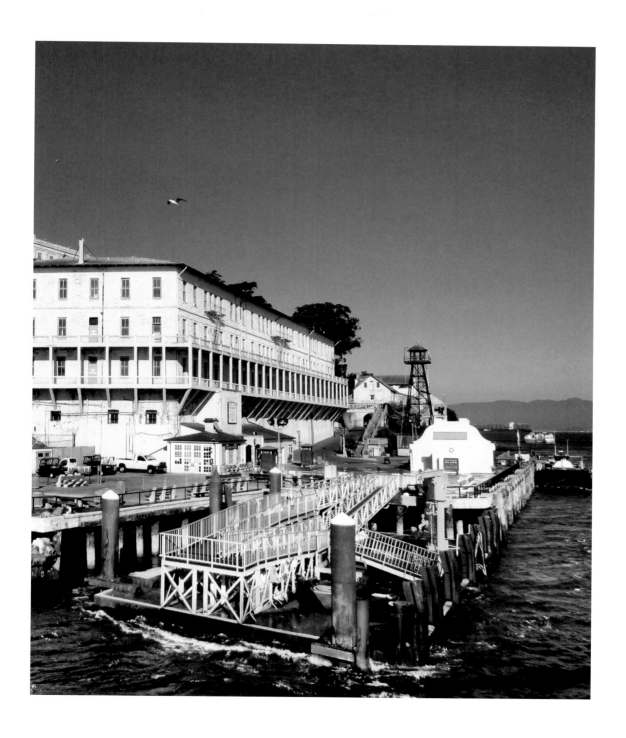

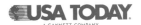

CAST AWAY

Yellowstone National Park has been a fly fishing destination for years.
One look at this picture and you'll know why.

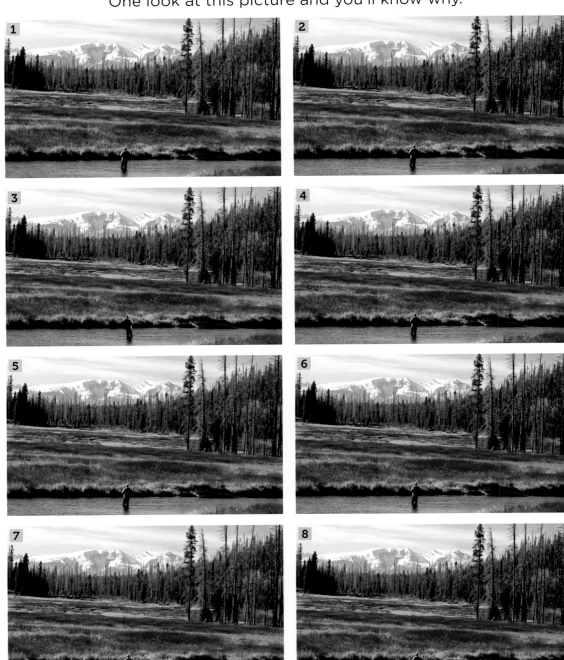

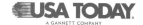

A-TRACK-TIVE SCENERY

A tour of the Rockies by rail puts otherwise inaccessible terrain on display.

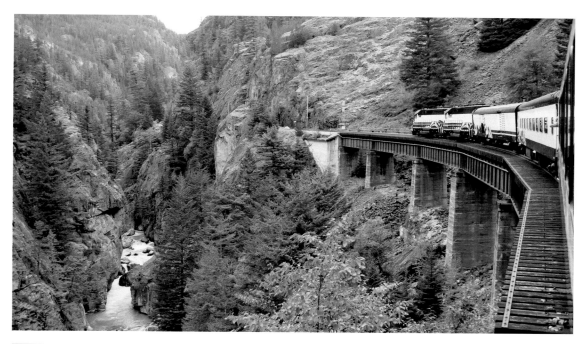

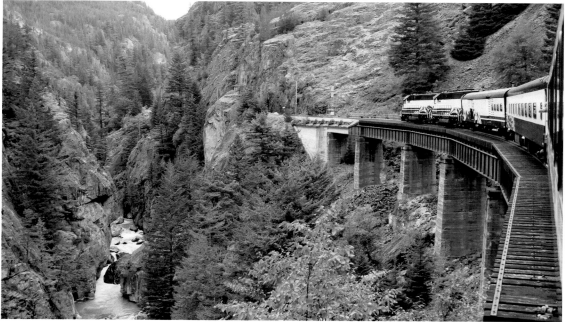

7 Changes ⬡⬡⬡⬡⬡⬡⬡

STAR PERFORMANCE

Blue Star Spring proves that Yellowstone's not a one-tint wonder.

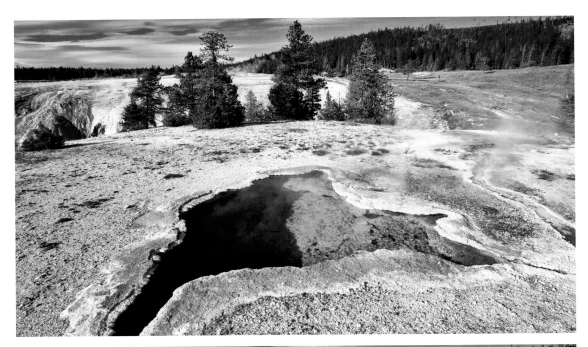

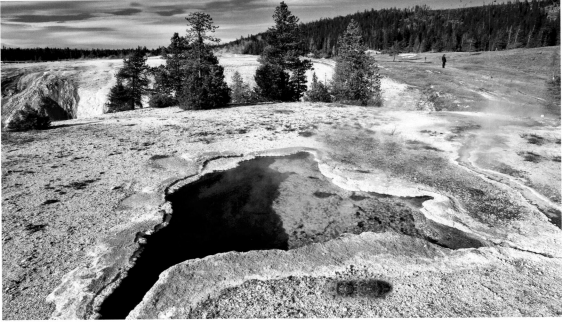

7 Changes

OH GUSH!

It's hard not to get swept away by the beauty of Niagara Falls, one of the natural wonders of the world.

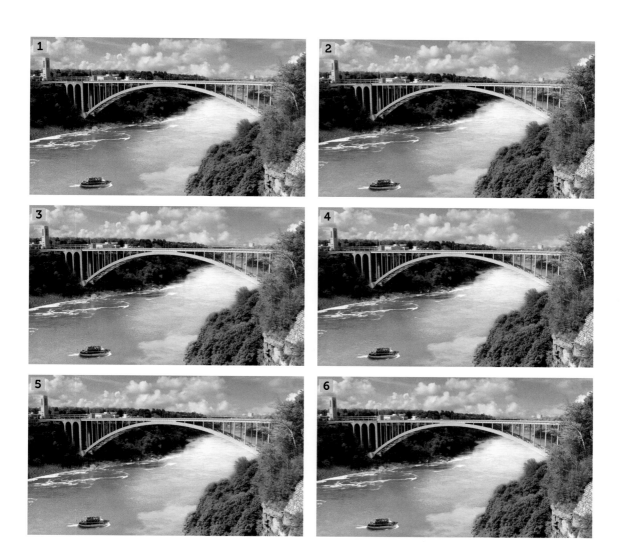

Rough
Road
Ahead

BIRTHPLACE OF THE SKYSCRAPER

From 1885's ten-story Home Insurance Building to the Willis Tower, Chicago is constantly breaking ground on new landmarks.

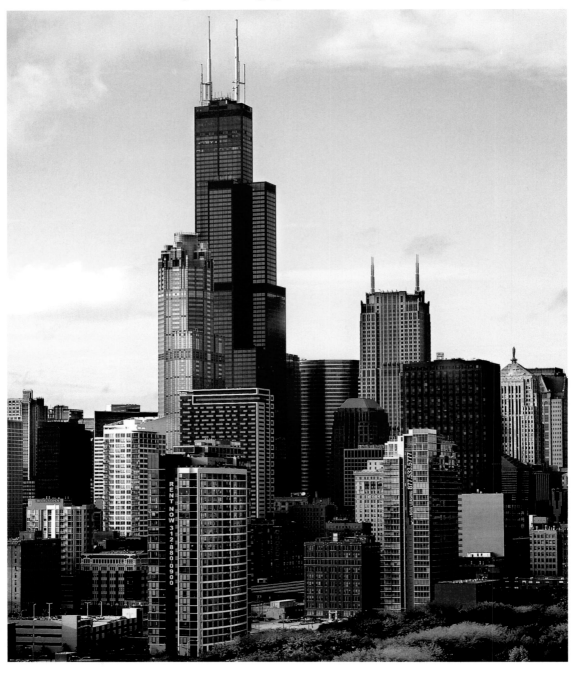

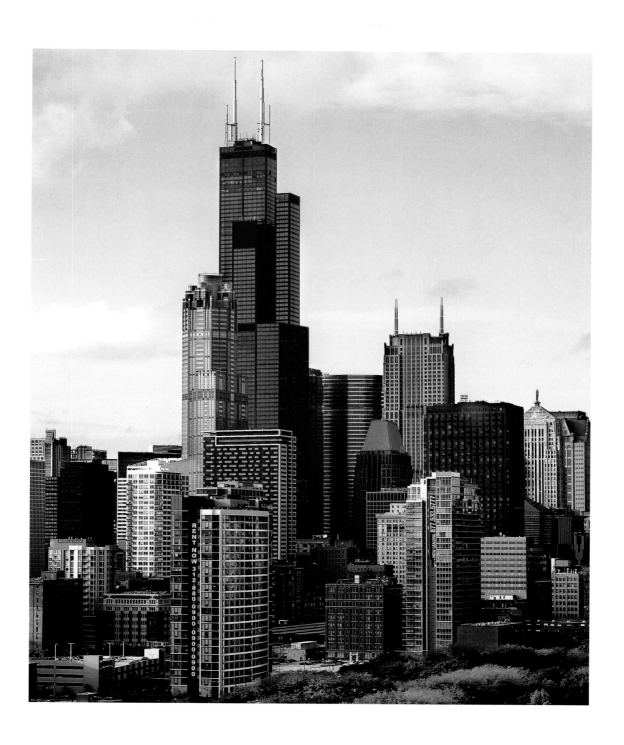

ON THE WATERFRONT

This isn't the first time that San Francisco's Presidio has induced "Vertigo."

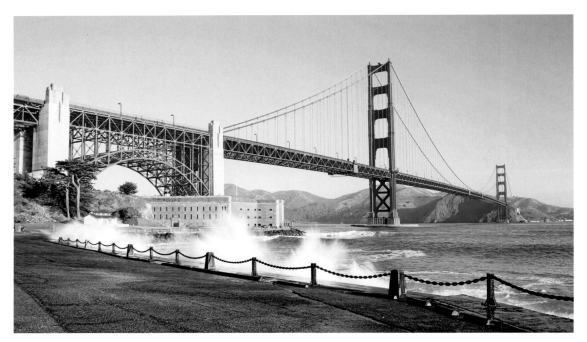

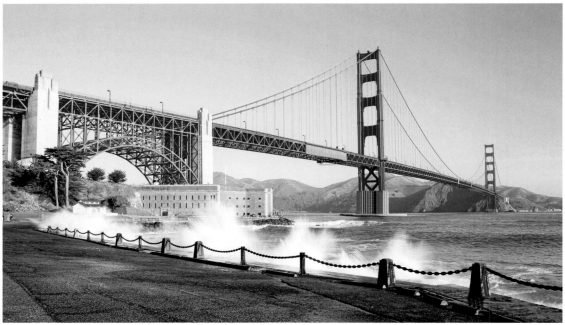

⬡⬡⬡⬡⬡⬡⬡ **7 Changes**

EGGS-TRAVAGANZA

Easter is a day for putting all our eggs in one basket.
But first take out the bad egg.

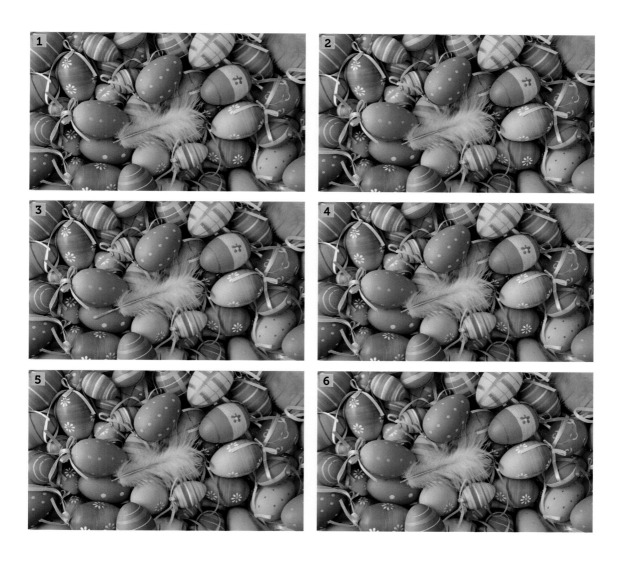

FIRE 'EM UP!

Not even New York City's bright lights can hold a Roman candle to its Fourth of July fireworks display.

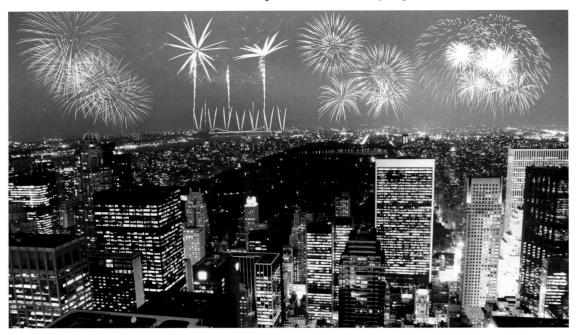

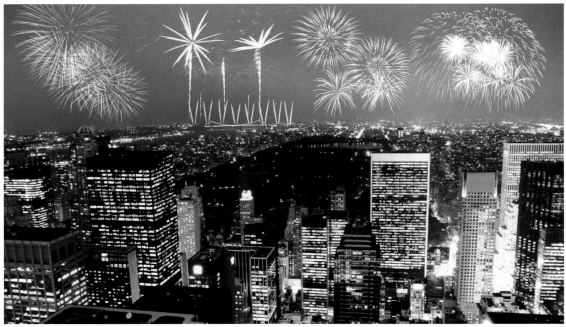

⬡⬡⬡⬡⬡ **6 Changes**

HAIL TO THE CHIEF

Has the West Wing flown the coop?
Figure out what's missing from the White House.

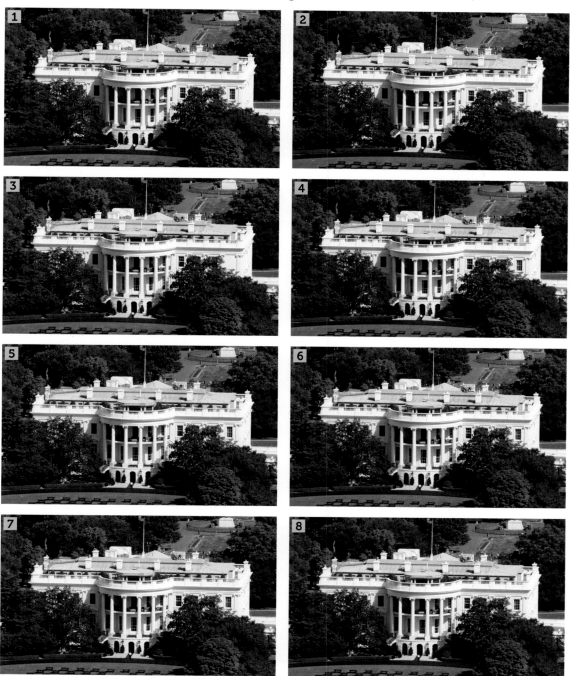

A FAMOUS IMMIGRANT

A century after the phrase "life, liberty, and the pursuit of happiness" was coined, the French commemorated it in copper.

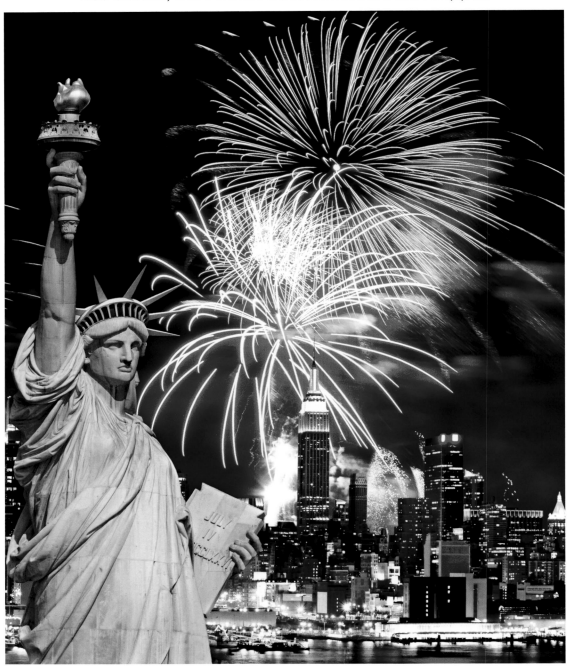

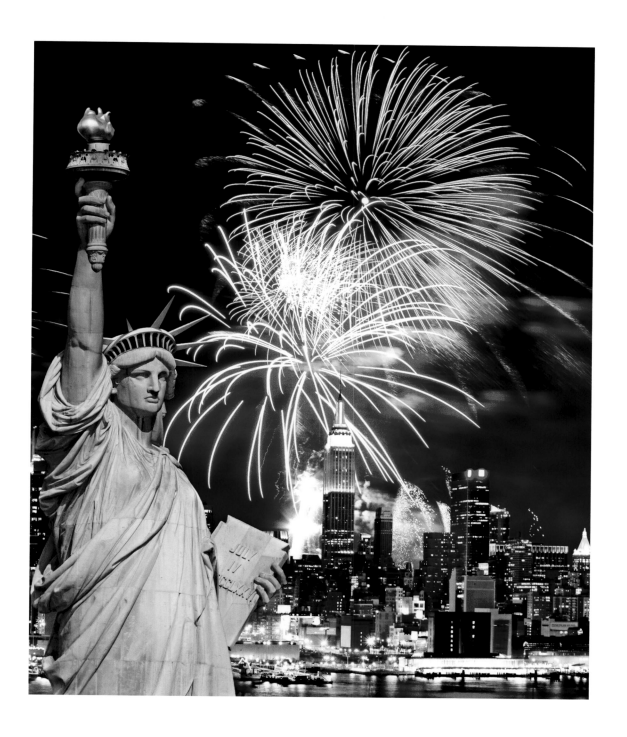

7 Changes ⬡ ⬡ ⬡ ⬡ ⬡ ⬡ ⬡

CATCH SOME WAVES

If you feel yourself flagging, just remember to stick it out.

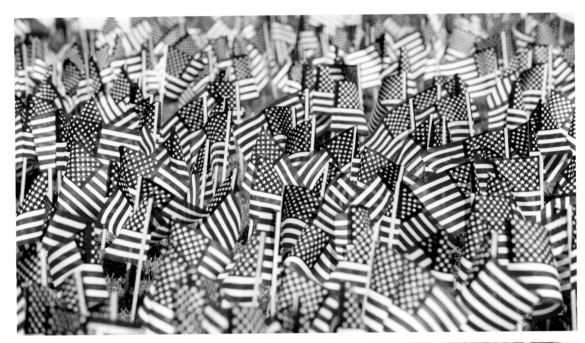

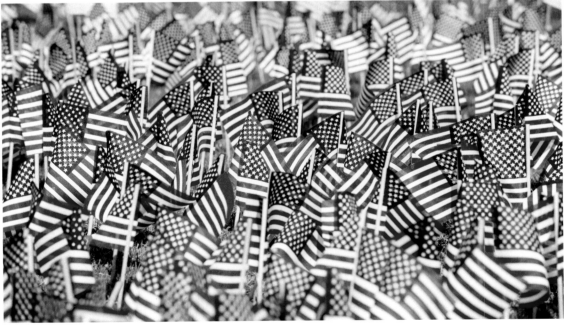

7 Changes

SHOW ME THE BENJAMINS

"Time is money," said Ben Franklin. We couldn't have said it better.

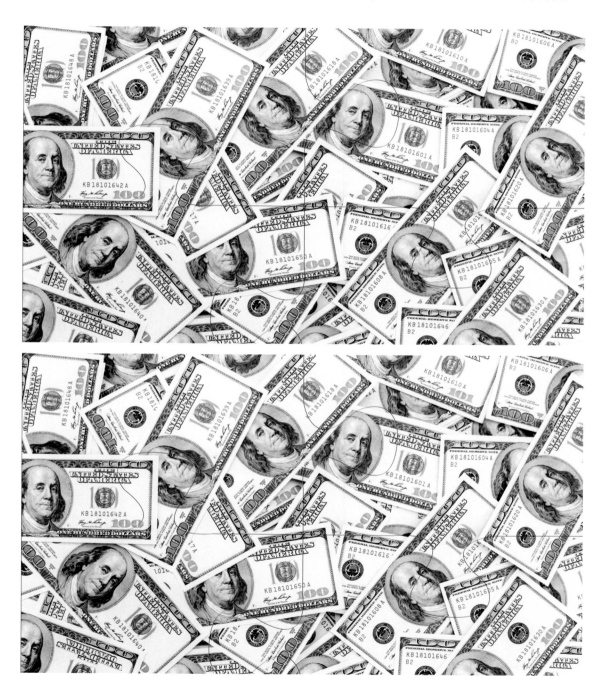

HONEST ABE

Blink and ... you'll miss 8 details that belie these "identical" photos.

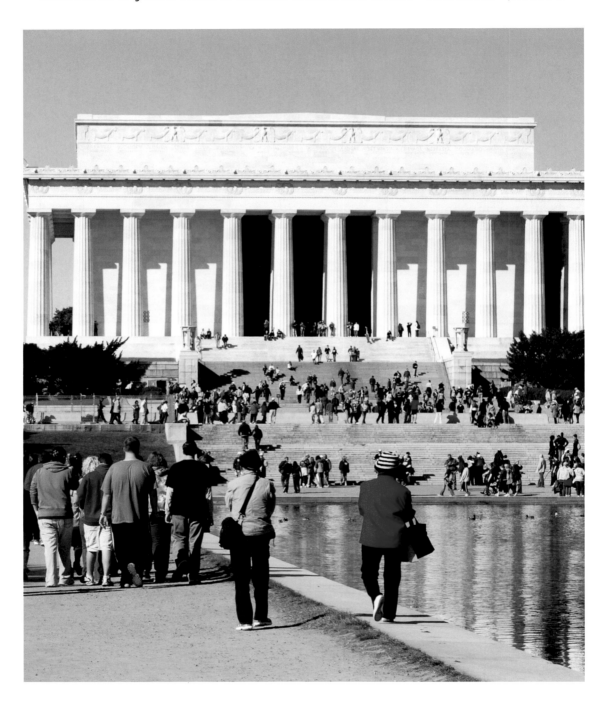

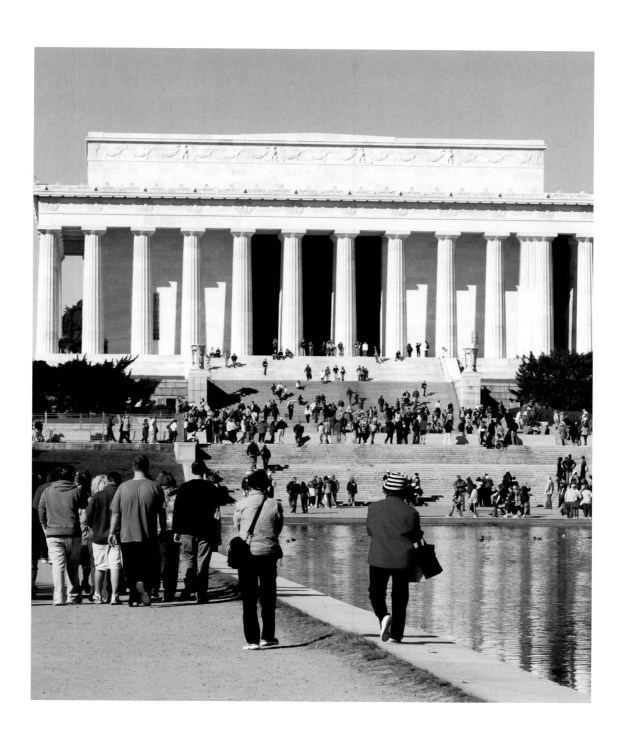

8 Changes ◯ ⬡ ⬡ ⬡ ⬡ ⬡ ⬡ ◯

MIAMI HEAT

Sun, sand, and sails—it's just another day in Miami.

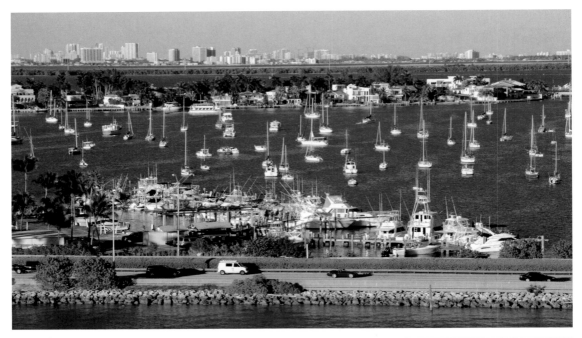

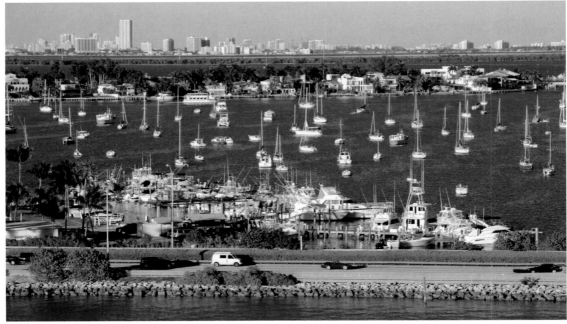

8 Changes

HELLO, MY NAME IS ...

The Orange County (FL) Convention Center is the USA's second largest, with plenty of room for 8 surprises.

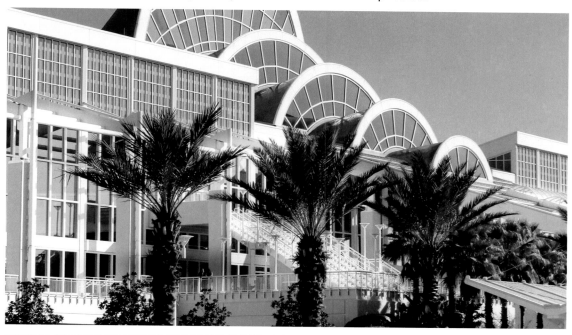

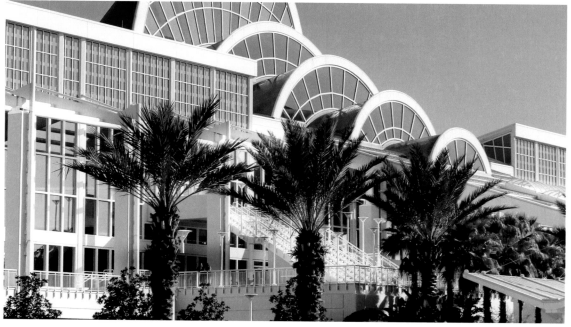

8 Changes ⬡⬡⬡⬡⬡⬡⬡⬡

MIAMI NICE

Put on your detective sunglasses, roll up your cuffs and sleuth out all 8 differences before they sail into the sunset.

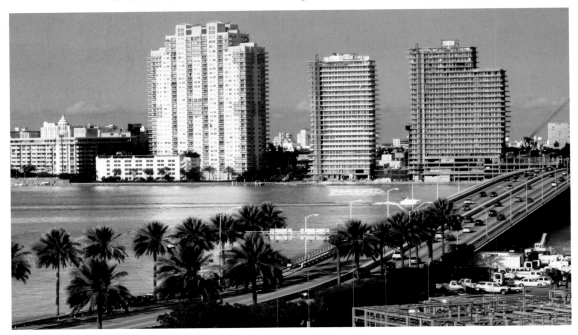

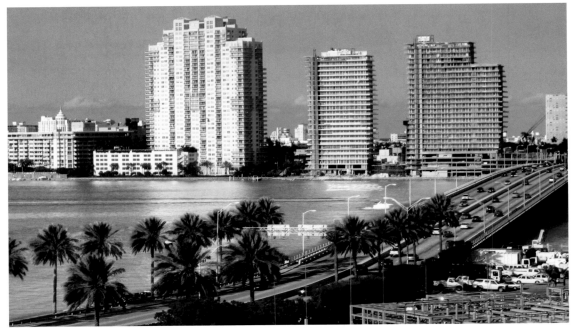

◯◯◯◯◯◯◯◯ **8 Changes**

SURF 'N' TURF

With its Mediterranean climate, Orange County (CA) makes a perfect getaway spot. Now spot what's getting away from this photo.

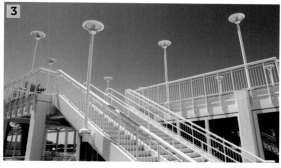

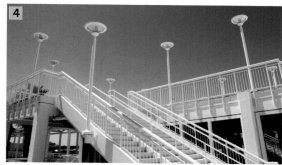

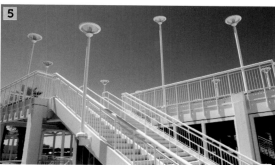

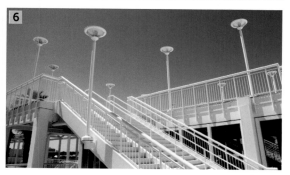

KNOCK KNOCK

Los Angeles is known as the City of Angels.
But what goes on behind closed doors?

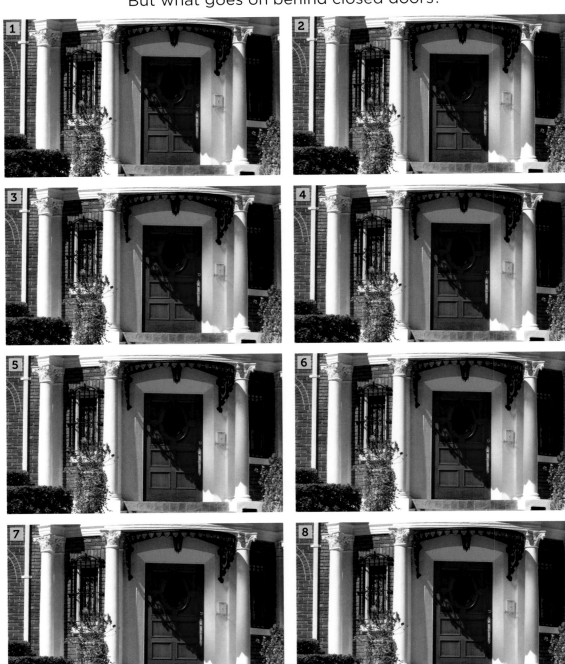

BOSTON LOCAL

With its quaint cobblestones and row houses, Beacon Hill's Acorn Street may be Boston's most photographed byway. (We snapped two.)

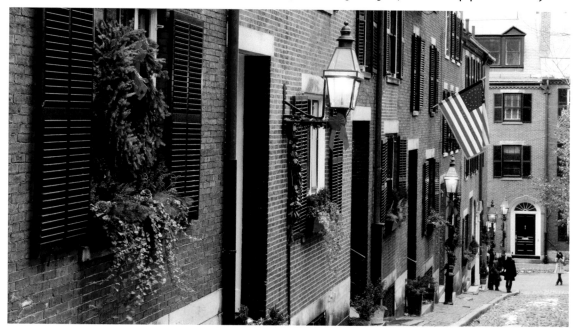

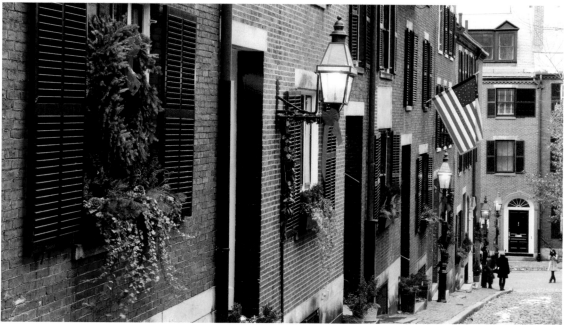

7 Changes ◯◯◯◯◯◯◯

VIVA LAS VEGAS

A walk down the strip will teach you a few tricks. Can you name 6?

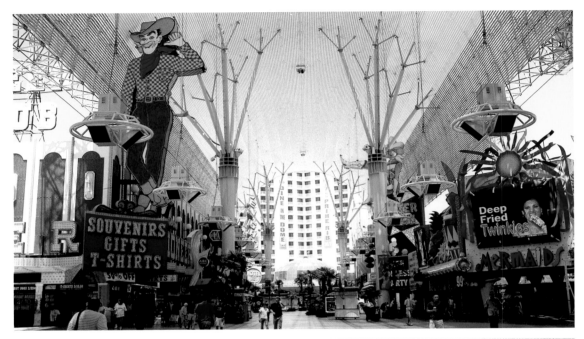

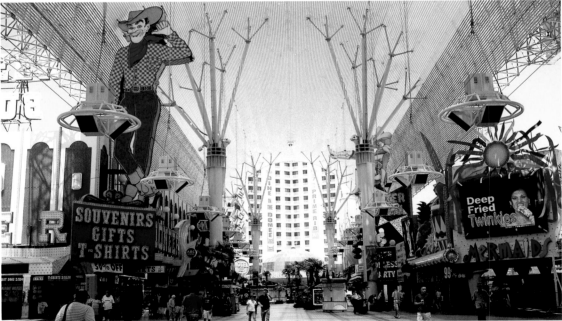

6 Changes

WATER UNDER THE BRIDGE

The Charles River runs past four universities before reaching the Atlantic Ocean. It may have picked up a thing or two along the way.

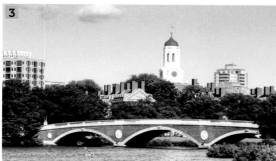

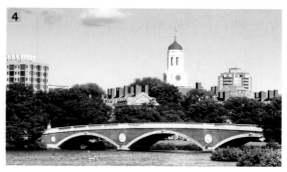

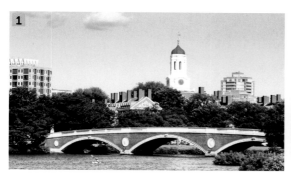

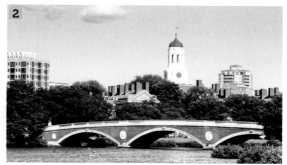

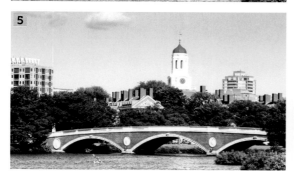

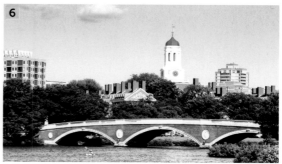

BAKED YOUR BEAN

These two photos have nearly everything in Boston common—
but not quite.

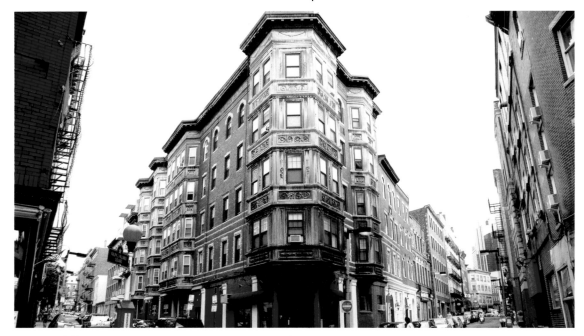

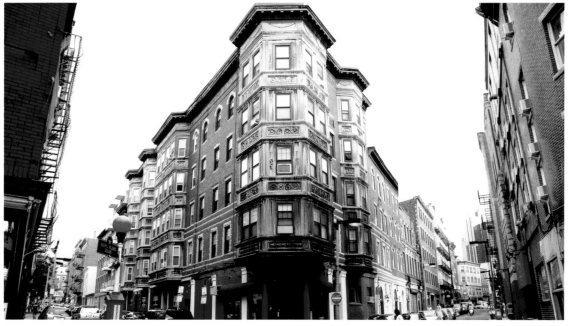

9 Changes

MOVIE MANIA

Many a Hollywood movie has been shot in Downtown Los Angeles. This picture has a few surprise cameos.

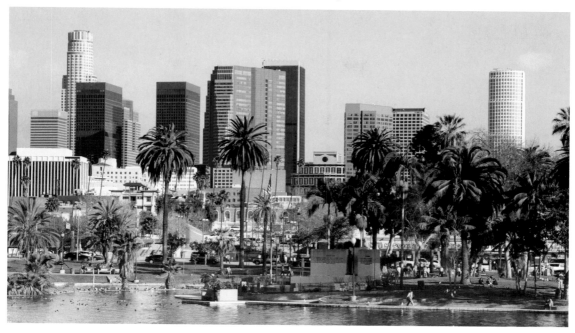

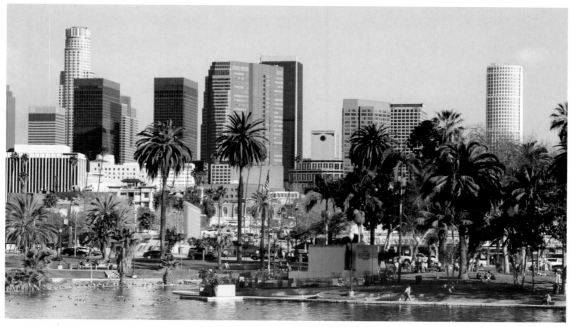

5 Changes ◯◯◯◯◯

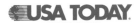

AHOY BUCCANEERS

Treasure Island lagoon marks the spot where you find 7 buried treasures.

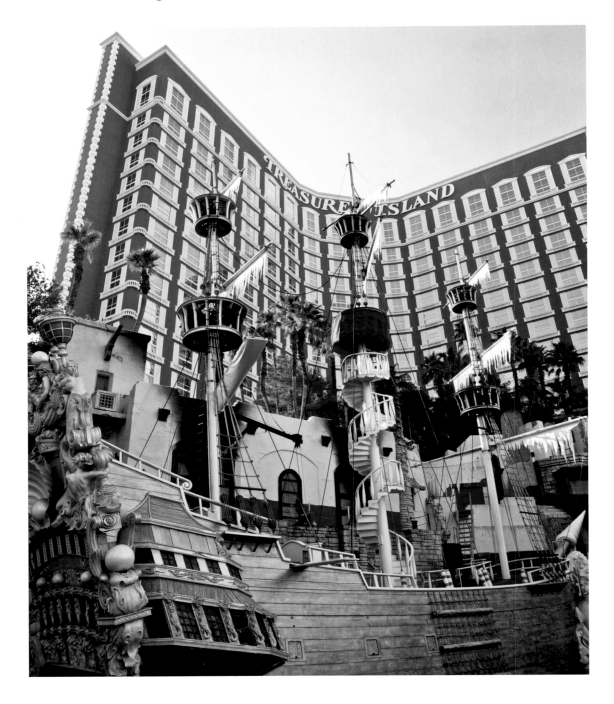

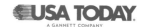

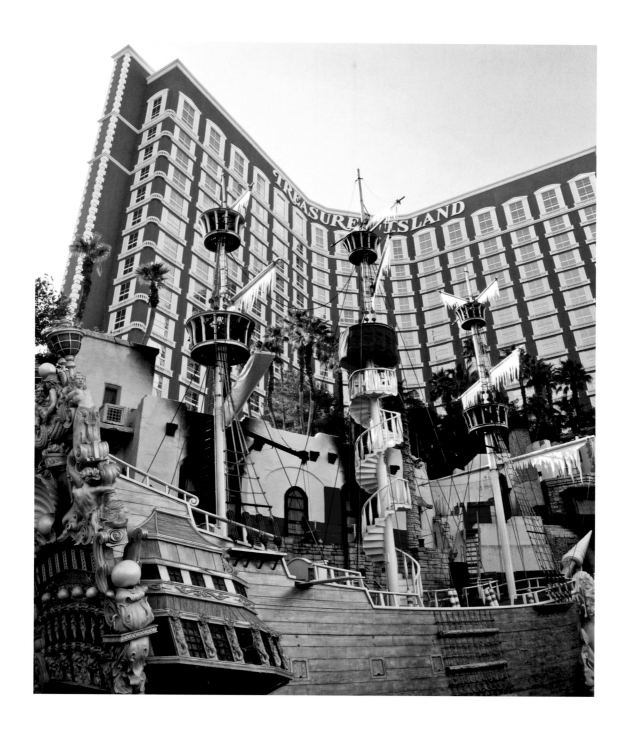

FUN IN STORE

A selection like this is a feast for the eyes. How do ya like them apples?

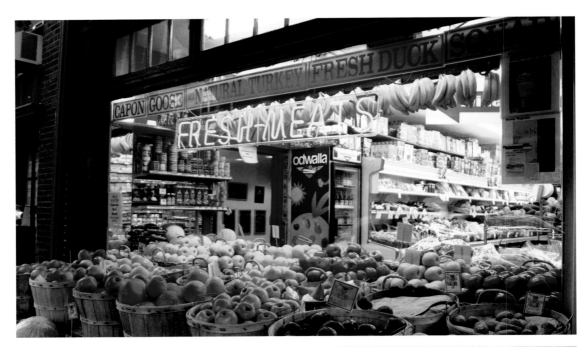

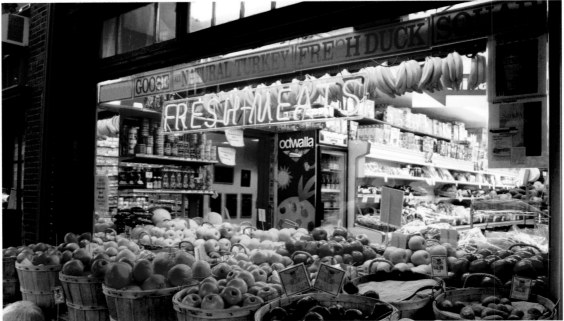

7 Changes

TOP OF THE HEAP

Midtown Manhattan features North America's most recognizable skyline.

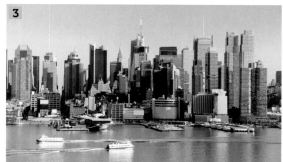

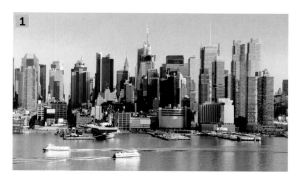

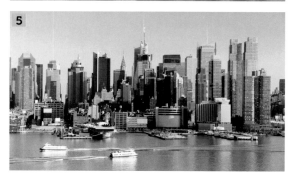

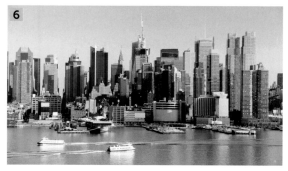

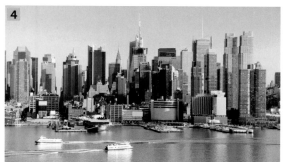

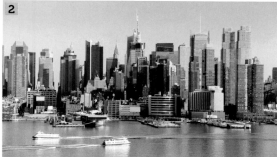

HOUSE HUNTING

Elegant brownstone homes line this Boston street. Pick the odd one out.

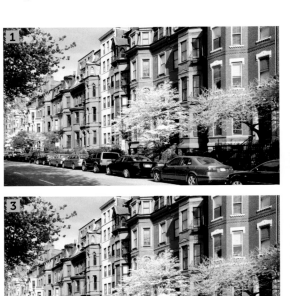

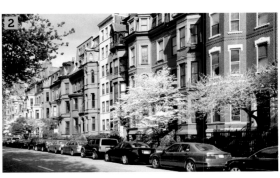

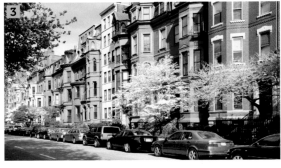

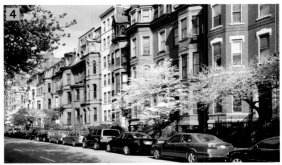

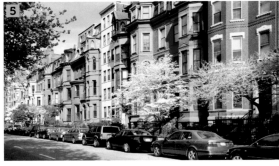

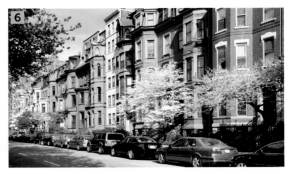

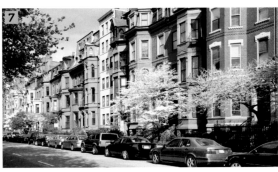

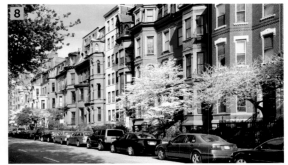

HIGH AND MIGHTY

New York's skyscrapers stand sentry to this glimmering city.

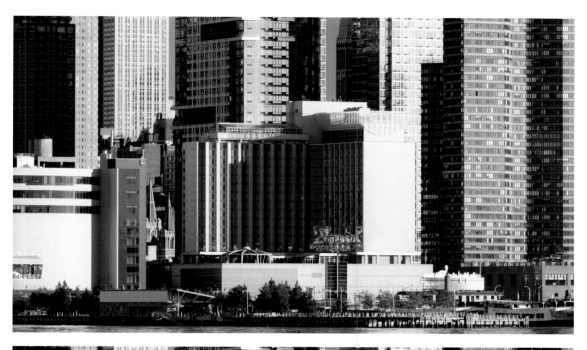

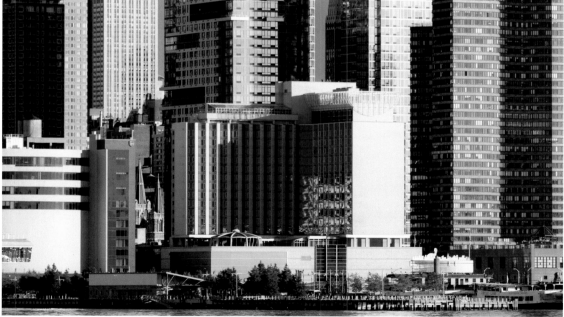

8 Changes ⬡⬡⬡⬡⬡⬡⬡⬡

TIMES A' CHANGIN'

At the heart of New York City, Times Square teems with an around-the-clock energy.

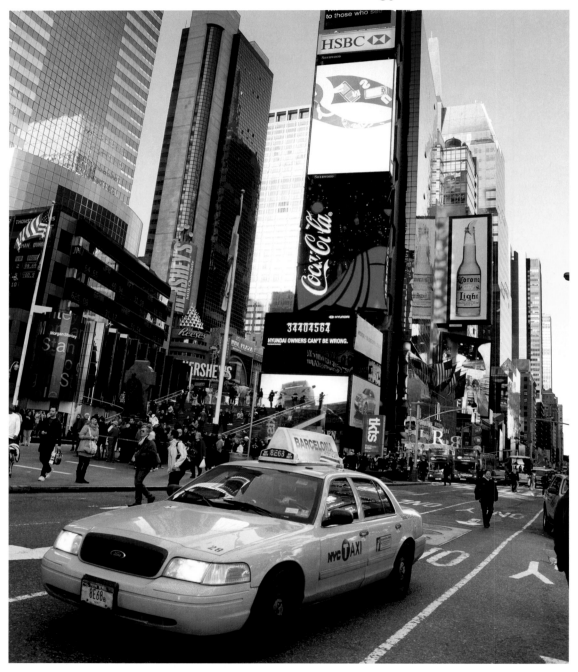

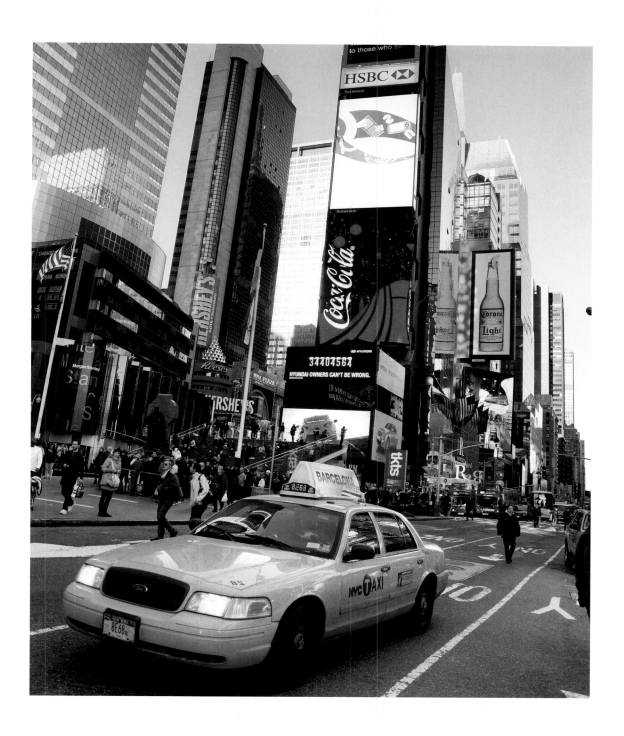

9 Changes ⬡⬡⬡⬡⬡⬡⬡⬡⬡

WINTER WONDERLAND

There's nothing more serene than gliding across the ice with the New York City skyline in the background.

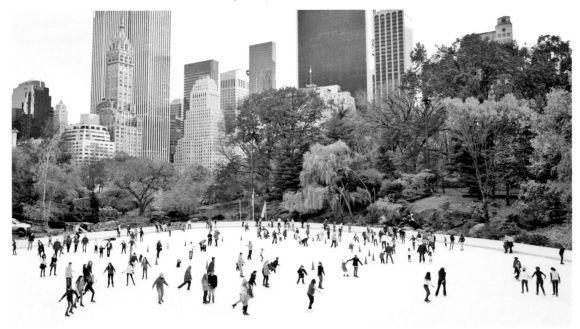

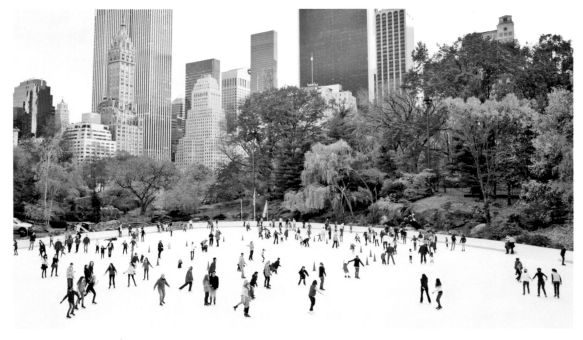

7 Changes

IN THE LOOP

The Chicago skyline rivals New York's for height and variety.
Keep looking up.

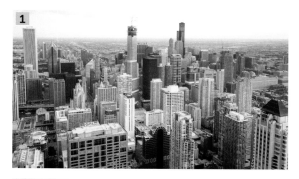

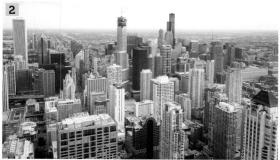

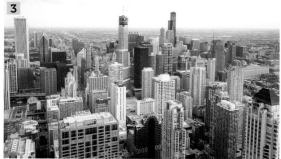

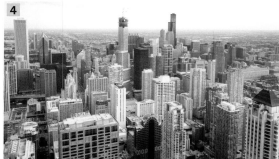

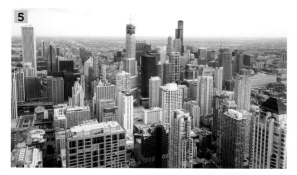

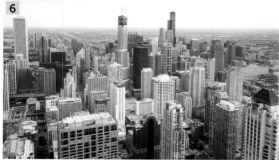

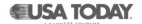

GO WEST

The Gateway Arch marks the westward expansion of the United States. It's your "manifest destiny" to expose the differences.

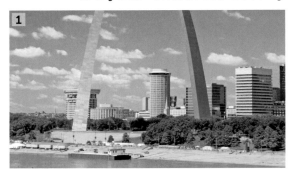

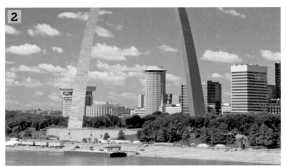

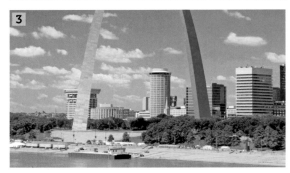

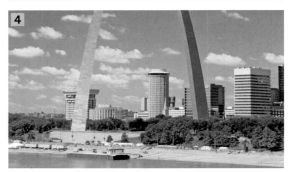

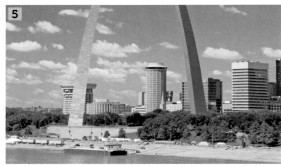

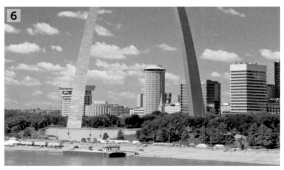

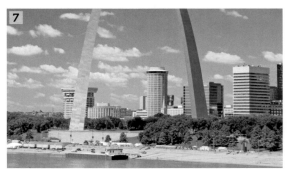

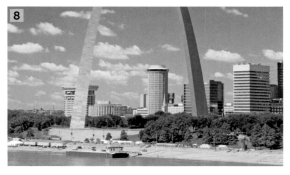

AT THE CENTER

Lake Eola is the centerpiece of Downtown Orlando and a hub for tourists.

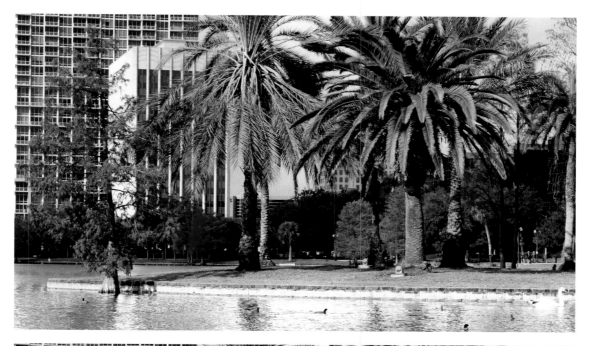

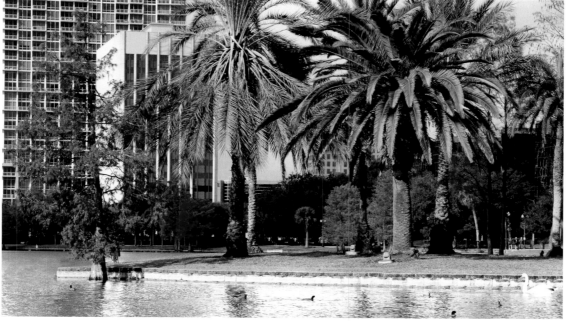

7 Changes ⬡⬡⬡⬡⬡⬡⬡

ANY GIVEN SUNDAY

It's a game of inches on the football field.
But before we move the chains, let's check the spot.

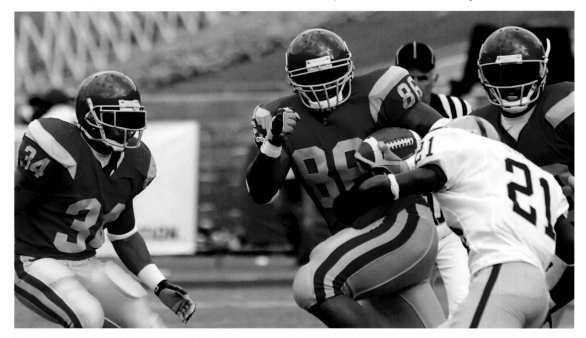

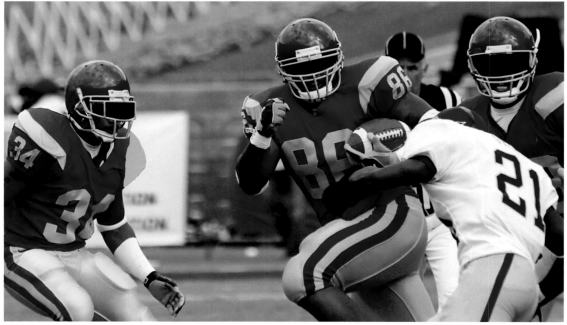

9 Changes

JOCKEYING FOR POSITION

Something in this horse race has gone off track. Can you spot it?

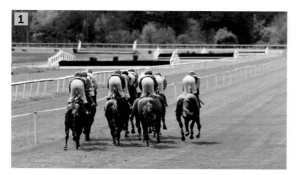

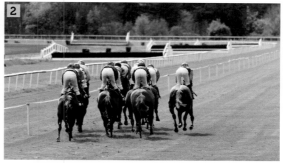

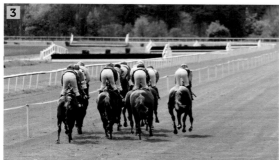

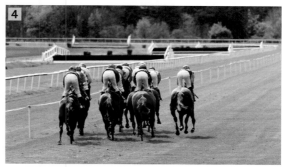

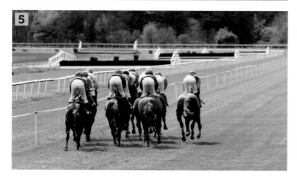

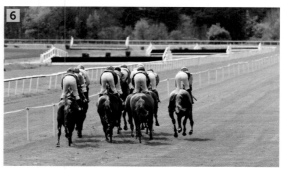

HORSING AROUND

Did somebody say "Marco?" Join the chase for 9 elusive items.

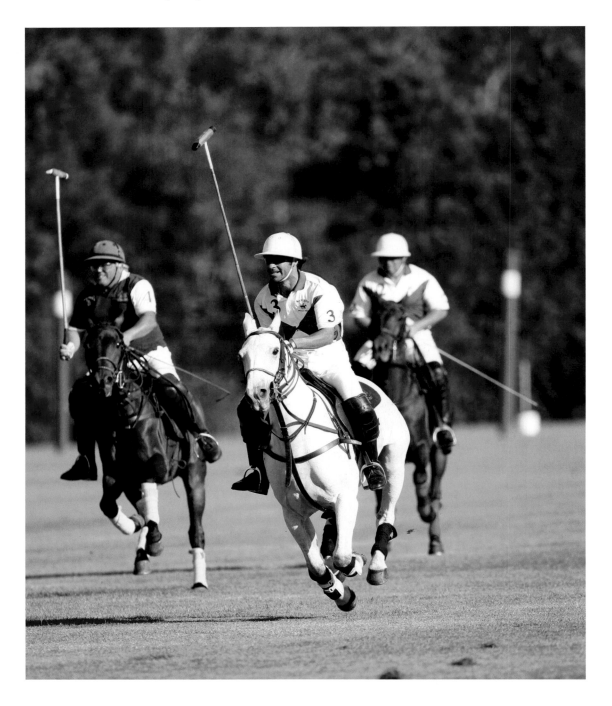

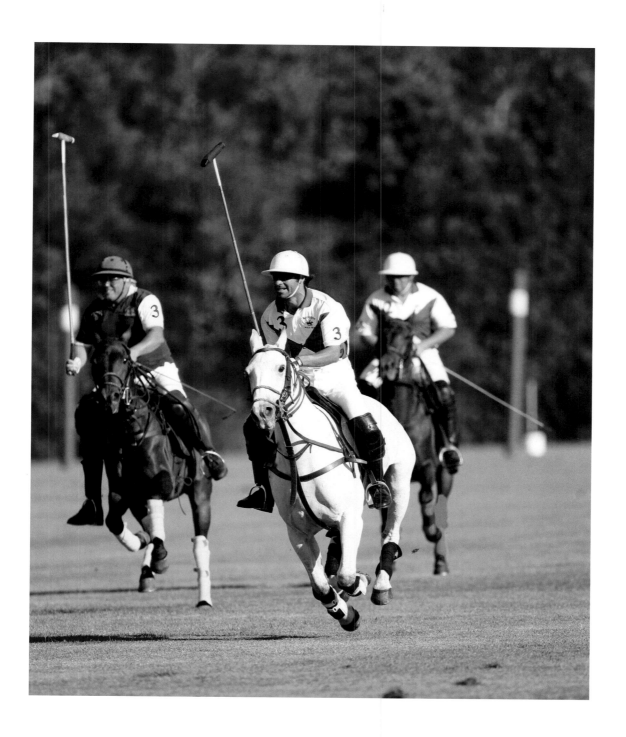

CALITRANSFORMATION

San Diego's beautiful scenery makes it difficult to imagine there are 8 things wrong with this picture.

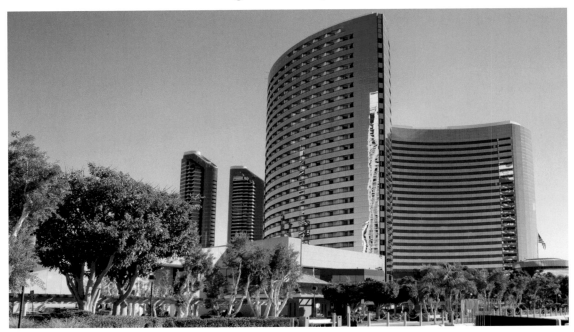

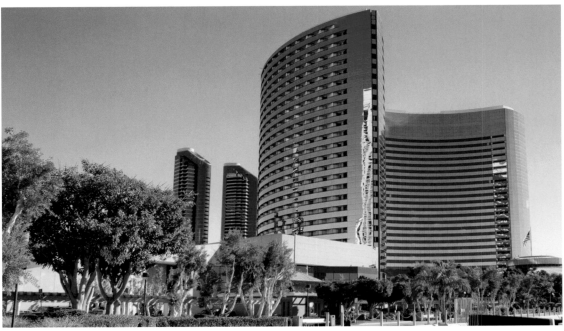

8 Changes

EQUESTRIAN IN CHIEF

A Boston statue of George Washington depicts him in command of the Continental Army. Rein in any rogue elements.

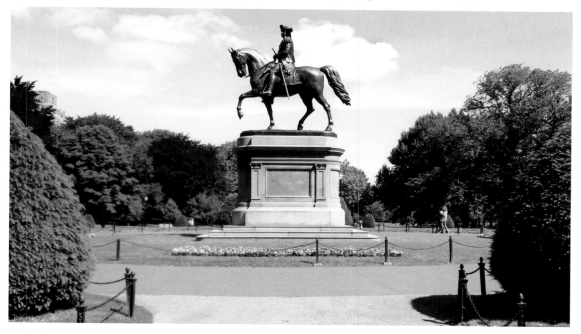

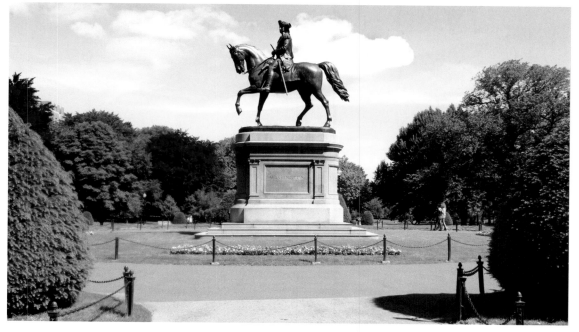

8 Changes ⬡ ⬡ ⬡ ⬡ ⬡ ⬡ ⬡ ⬡

SEA TO SKY

Poised between azure waters and cerulean skies, the 200-foot high
Coronado Bridge connects downtown San Diego to Coronado Island.

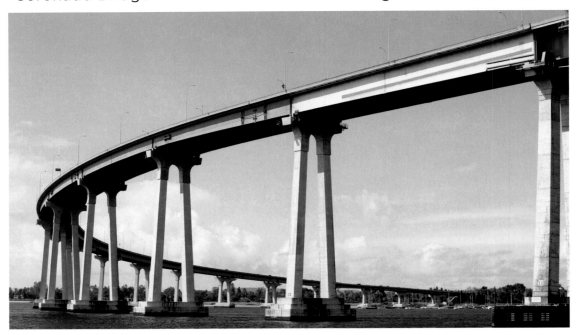

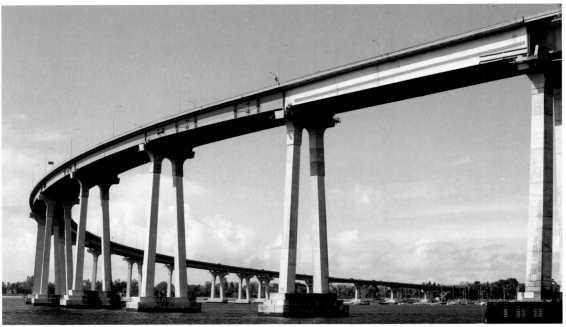

7 Changes

LIFE ON THE MISSISSIPPI

This steamboat is rollin', rollin', rolling on the river.
Make sure the big wheel keeps on turning.

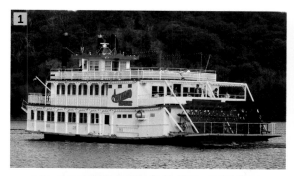
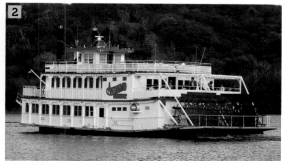
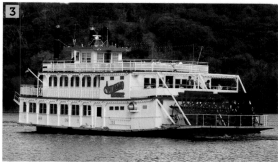
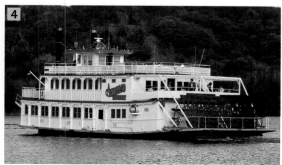
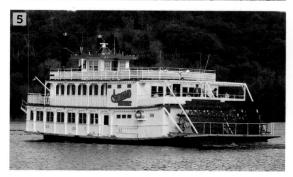
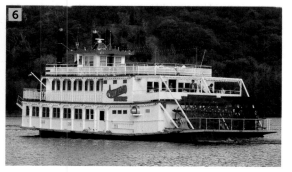

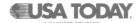

RIVER REFLECTIONS

The Mississippi (usually) mirrors this beautiful image perfectly.

'M'-PLOY YOUR 'I'-SIGHT

R U OK 2 C? The Guinness Book of Records calls the
Hernando de Soto bridge "the largest freestanding letter of the alphabet."

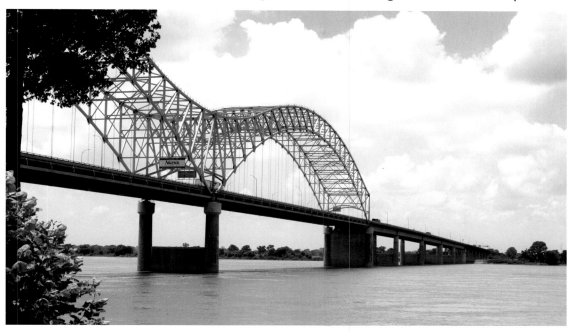

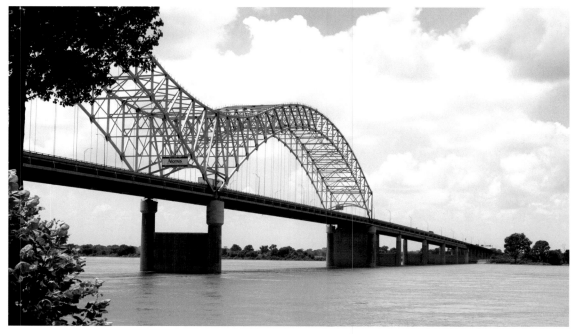

7 Changes ⬡⬡⬡⬡⬡⬡⬡

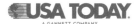

DOWN BY THE CREEK

Polecat Creek is the perfect picnic location. If you're lucky, you'll spot a wild cat—but for now, just spot the odd one out.

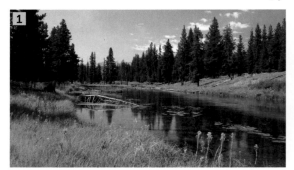

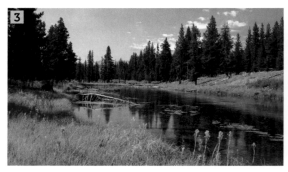 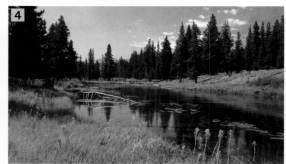

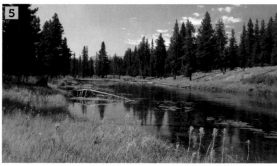 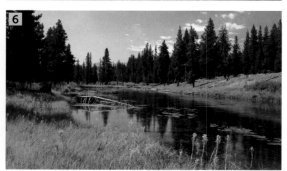

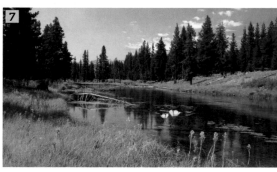 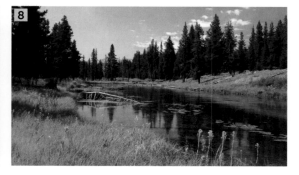

MILE-WIDE MEANDER

Midway across one of Mississippi's historic bridges, you realize what they meant about not changing horses.

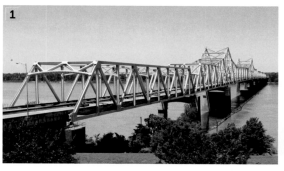

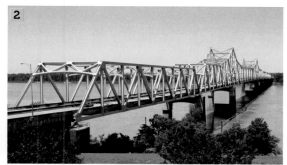

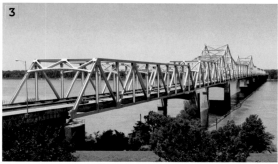

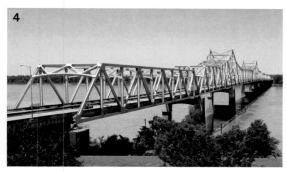

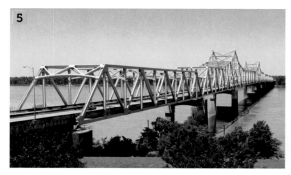

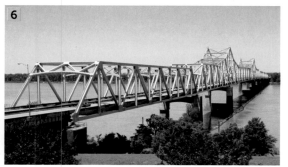

ROCK LIKE AN EGYPTIAN

Shaped like an Egyptian obelisk, the Washington Monument is the world's tallest stone structure, visible in clear weather for up to 40 miles.

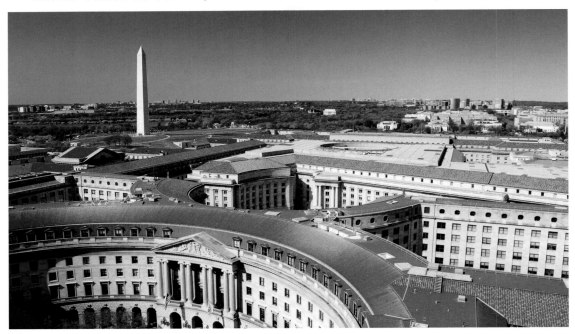

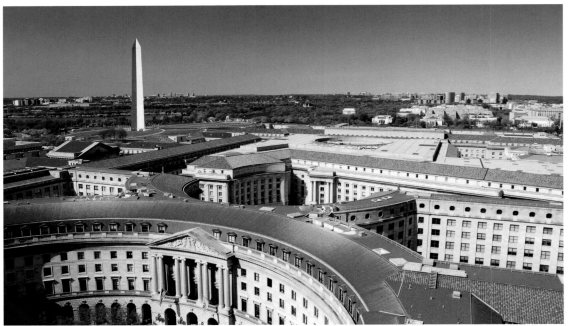

6 Changes

Solutions

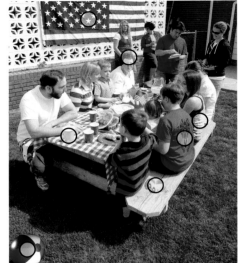

Page 9

Page 10

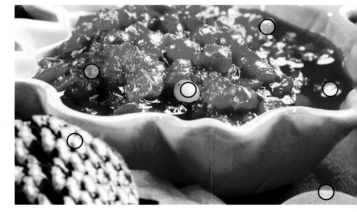

Page 11

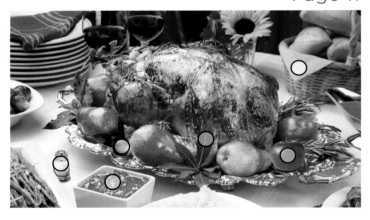

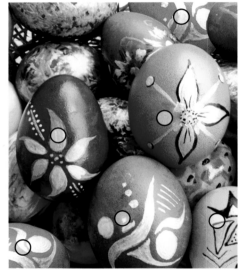

Page 13

Page 14

Page 1

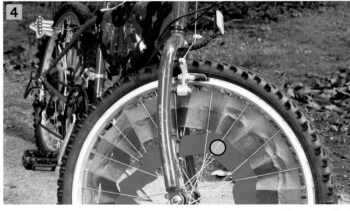

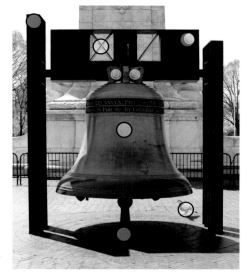

Page 17

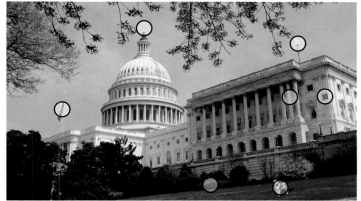

Page 18

Page 19

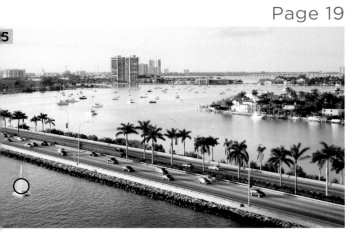

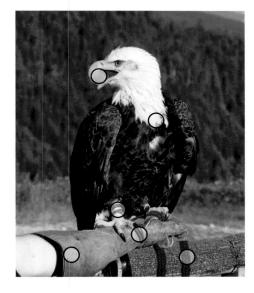

Page 21

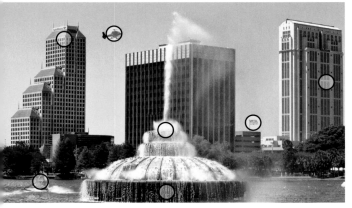

Page 22

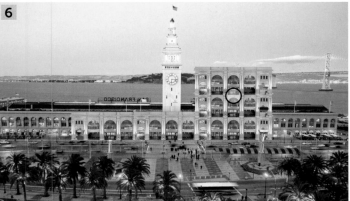

Page 23

Page 26

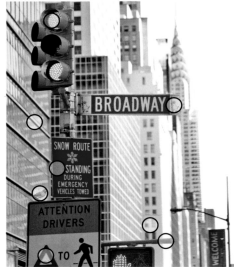

Page 25

Page 27

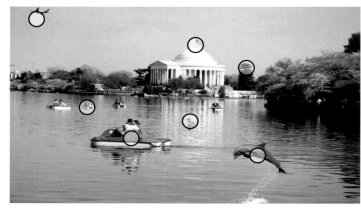

Page 29

Page 30

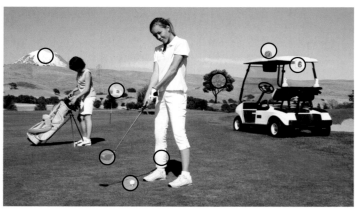

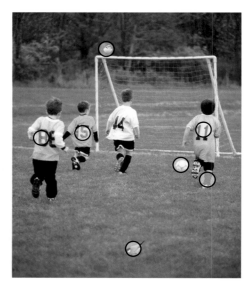

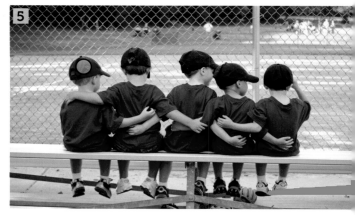

Page 31

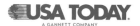

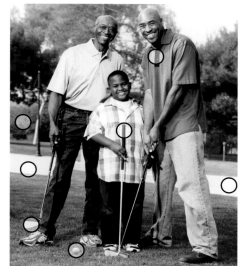

Page 33

Page 34

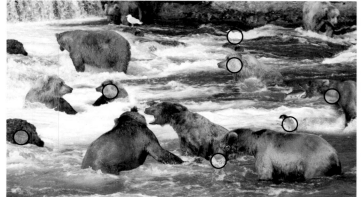

Page 35

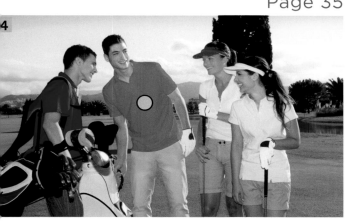

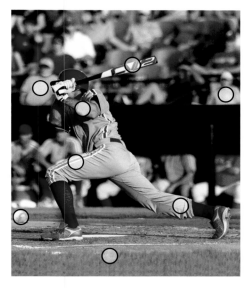

Page 37

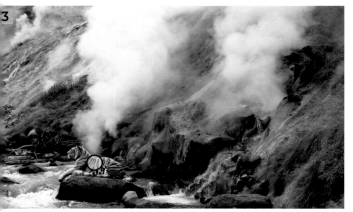

Page 38

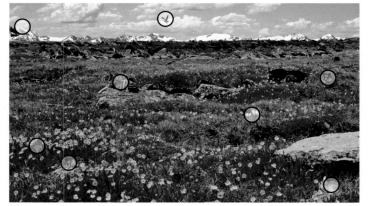

Page 39

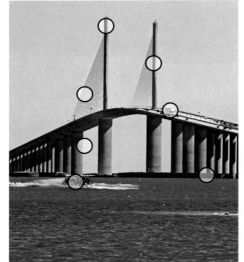

Page 41

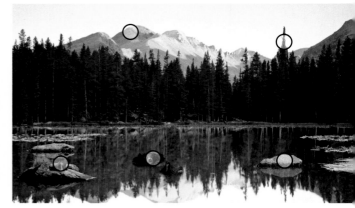

Page 43

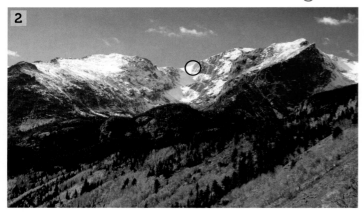

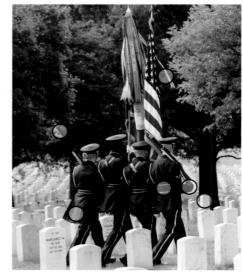

Page 47

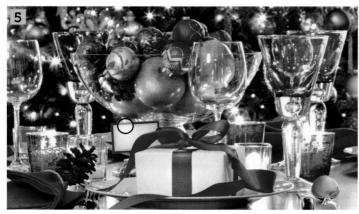

Page 48

Page 4

Page 50

Page 51

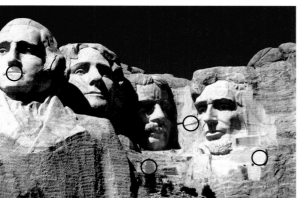

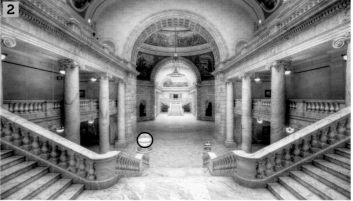

Page 54

Page 53

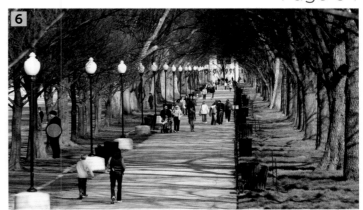

Page 55

Page 56

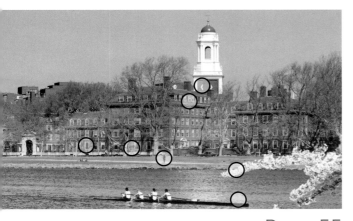

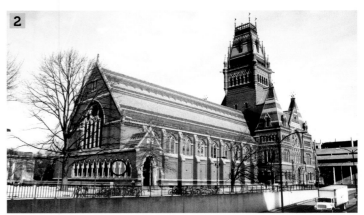

Page 57

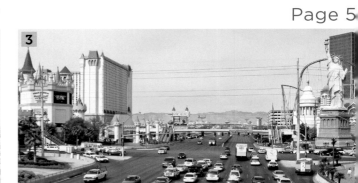

Page 5

Page 59

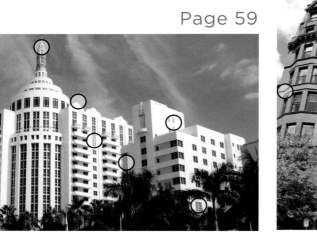

Page 61

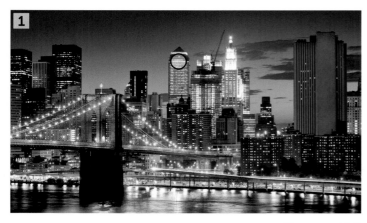

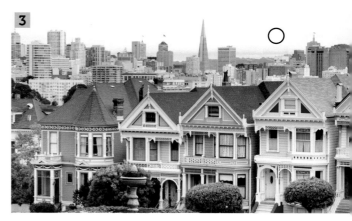

Page 62

Page 6

Page 64

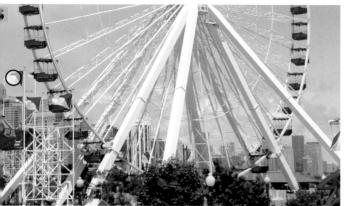

Page 65

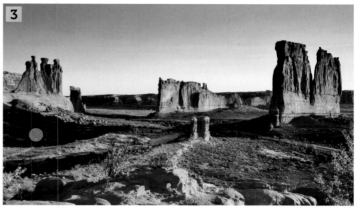

Page 66

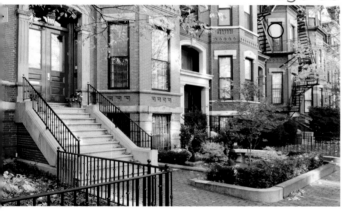

Page 67

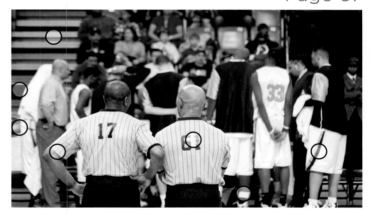

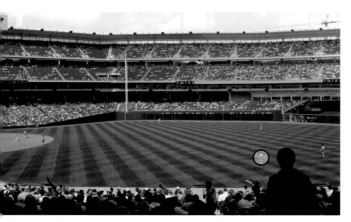

Page 68

Page 69

Page 70

Page 7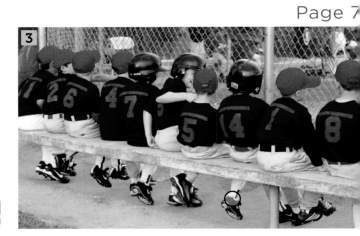

Page 7

Page 73

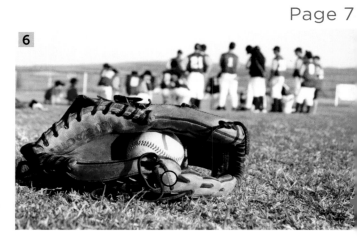

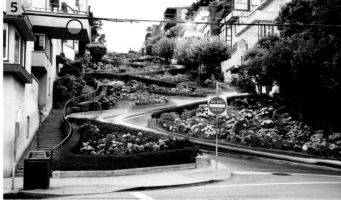

Page 75

Page 7

148 Solutions

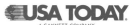

Page 77

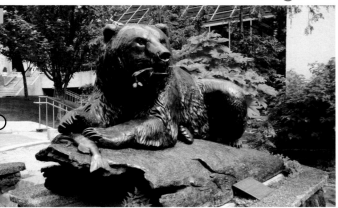

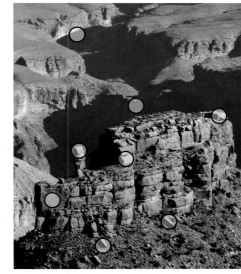

Page 79

Page 80

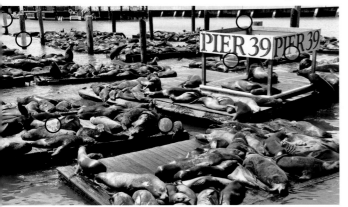

Page 81

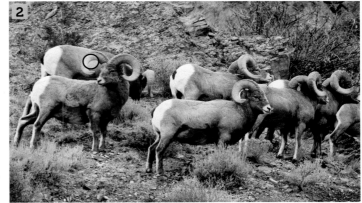

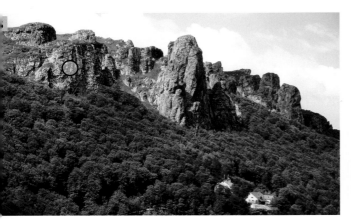

Page 82

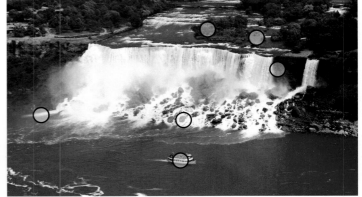

Page 83

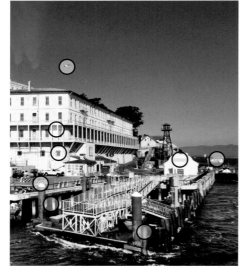

3

Page 85

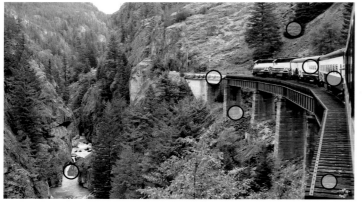

Page 87

Page 8

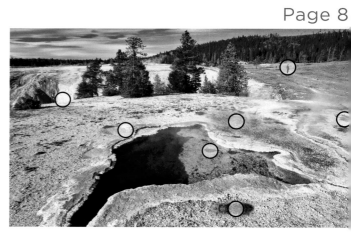

6

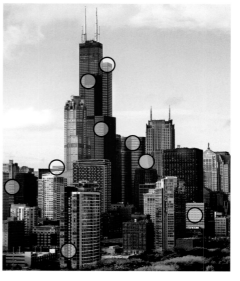

Page 89

Page 93

Page 94

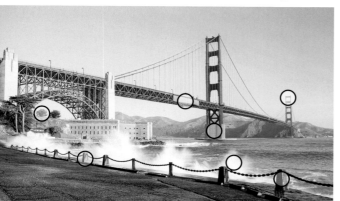

Page 95

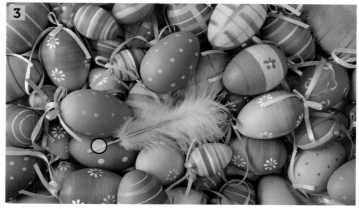

Page 96

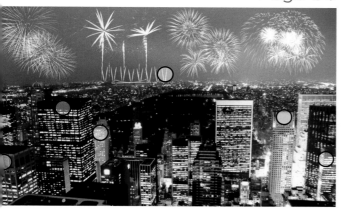

Page 97

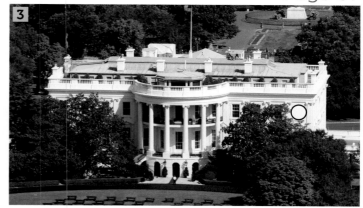

Page 99

Page 100

Solutions 151

Page 101

Page 103

Page 104

Page 10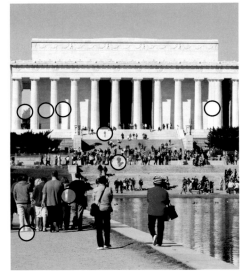

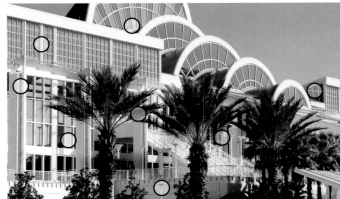

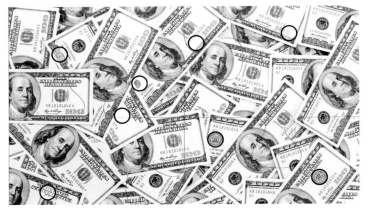

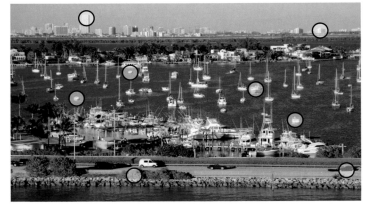

5

Page 106

Page 10

Page 108

Page 109

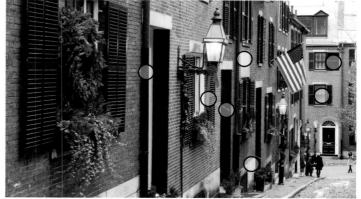

Page 110

Page 111

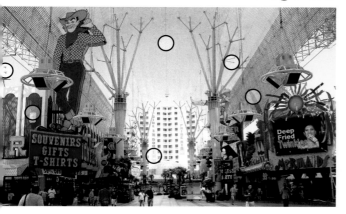

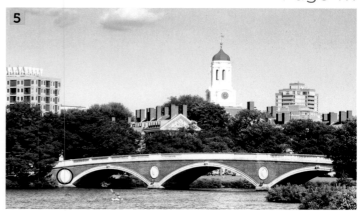

Page 112

Page 113

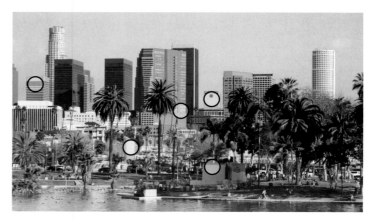

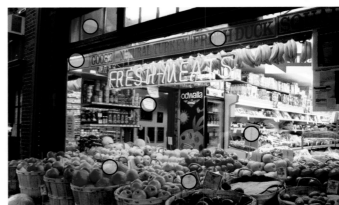

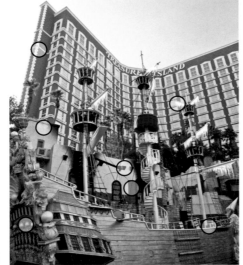

Page 115

Page 117

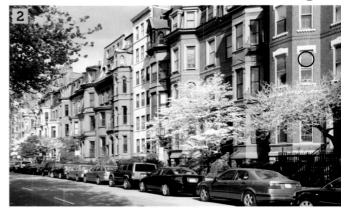

Page 1

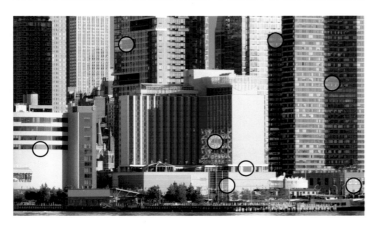

Page 119

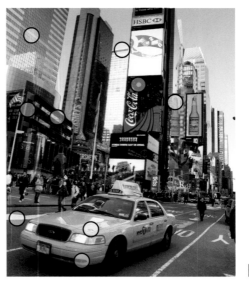

Page 121

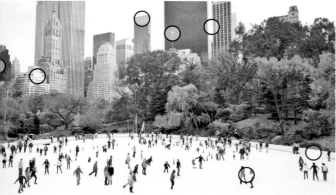

Page 122

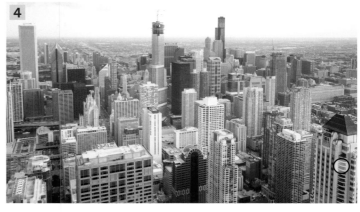

Page 123

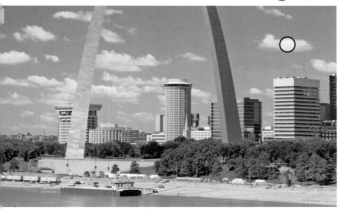

Page 124

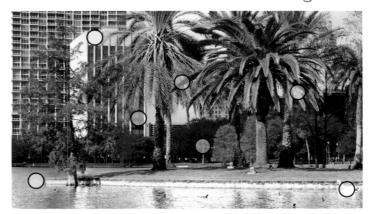

Page 125

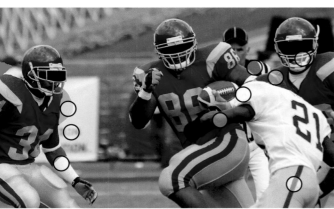

Page 126

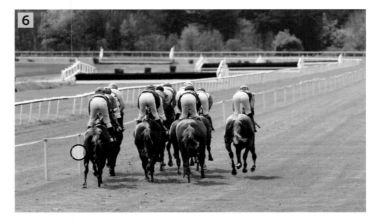

Page 127

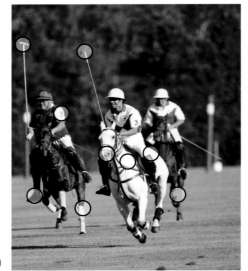

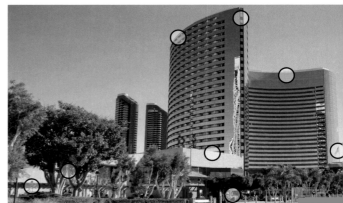

Page 129

Page 131

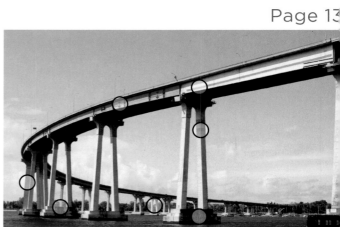

4

Page 133

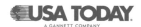

Page 135

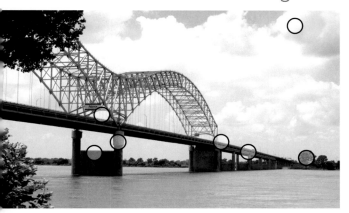

Page 136

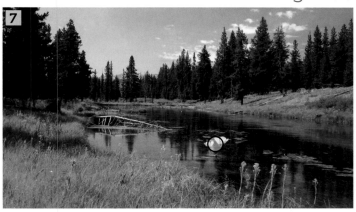

Page 137

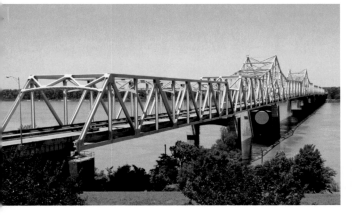

Page 138

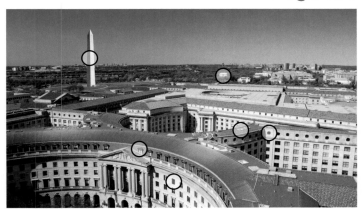